W9-BRU-008

A Modern
Photo
Guide

White
ping
nting

Minolta Corporation
Ramsey, New Jersey

Doubleday & Company
Garden City, New York

Photo Credits: All the photographs in this book were taken by the editorial staff unless otherwise credited. Cover: J. Alexander; p.3: B. Sastre; p. 4: K. Tweedy-Holmes

Minolta Corporation
Marketers to the Photographic Trade

Doubleday & Company, Inc.
Distributors to the Book Trade

This book and the other books in the Modern Photo Guide Series were created and produced by Avalon Communications, Inc. and The Photographic Book Co., Inc.

Library of Congress Catalog Card Number 81-71226
ISBN: 0-385-18164-7

Cover and Book Design: Richard Liu
Typesetting: Com Com (Haddon Craftsmen, Inc.)
Printing and Binding: W. A. Krueger Company
Paper: Warren Webflo
Separations: Spectragraphic, Inc.

Manufactured in the United States of America
10 9 8 7 6 5 4 3 2 1

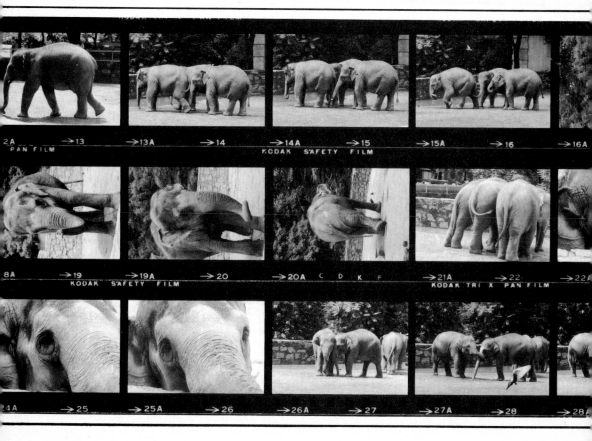

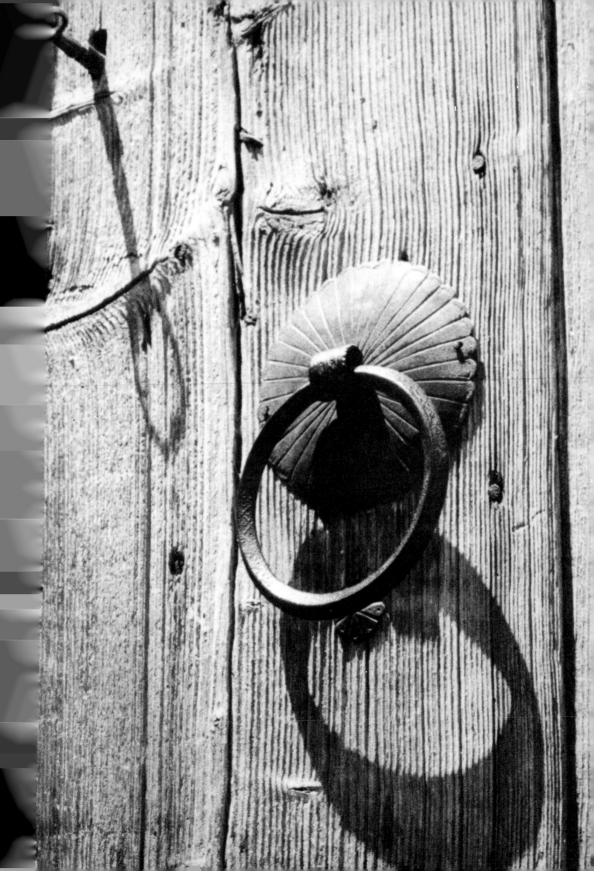

Contents

Technique Tips

Throughout the book this symbol indicates material that supplements the text and which has been set off for your special attention. You can apply the data and information in these Technique Tips immediately to get better results in your photography.

Introduction
The Complete Photographer

With your camera, you capture an image on film: a scenic landscape, a dramatic action, a favorite expression on a loved one's face. If you take or send the film elsewhere to be developed and printed, you lose any further control over how the picture will look. This may work out fine much of the time, but if you are beginning to think more seriously about getting better prints, or if you want to get even more pleasure from a hobby you already enjoy, the next step is to set up your own home darkroom.

You may also have been disappointed many times in your commercially produced photographs, but never realized that those prints need not have looked so drab or washed out.

The basic techniques of developing film and making prints are easy to master, and it shouldn't be too difficult to find a place to work. Almost all houses and apartments have some space suitable for at least a temporary darkroom. Doing your own work is inexpensive as well. There will be a modest initial expense for equipment and supplies, but after that you can cut your processing costs considerably.

With your own darkroom, *you* are in control, and you have many methods at your disposal for determining how the print will look. For instance, you can increase or reduce contrast in numerous ways, and there are many techniques that will enable you to get excellent results from even hard-to-print negatives.

The purpose of this book is to show you how to set up and equip your darkroom, and how to use it to get the kind of pictures you want. The skills you gain will give you greater assurance as a photographer and, just as important, they will make photography more fascinating and more fun.

Exposure alone will not guarantee the best rendition of your subject—you also need accurate processing and careful printing to realize the full visual potential of your photographs. Photo: K. Tweedy-Holmes.

1

The Darkroom

A darkroom is truly essential only for enlarging and printing. In film developing, darkness is essential only when loading the roll of film into the developing tank, and any space that can be temporarily (but completely) blacked out is sufficient. Or you can do away with the need for darkness altogether by loading the tank in a changing bag (a double-layered, lighttight bag with elasticized sleeves to give you access).

When planning a darkroom, remember that an elaborate setup is not necessary for getting good prints. If you do your work well, you will get excellent results in even the most basic, temporary darkroom.

Do some careful planning before you buy any of the items needed for your permanent darkroom. Measure out the space available, and make sketches of potential layouts. Leave as much storage and workspace as the room will allow; keep the wet and dry areas away from each other. The darkroom shown here is laid out in logical order, allowing an easy flow of operations from negative selection to enlarging, through the processing stages, then to washing and drying.

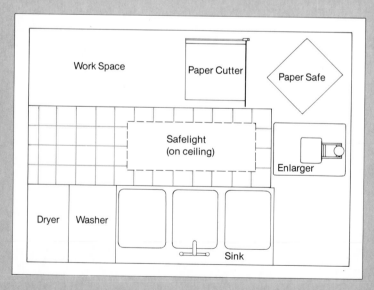

In this informal portrait, the photographer darkened (burned in) the background while printing, bringing the viewers' full attention to the subjects' faces. Photo: K. Tweedy-Holmes.

➤

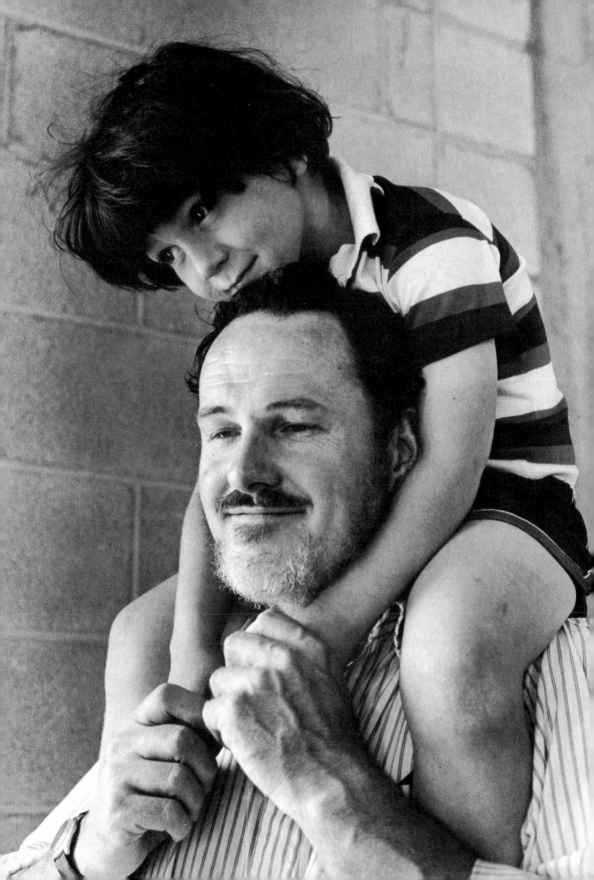

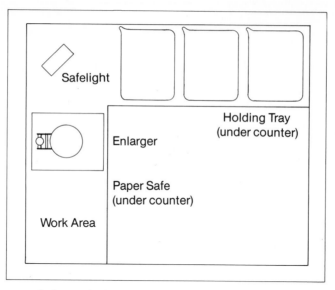

Safelight

Holding Tray
(under counter)

Enlarger

Paper Safe
(under counter)

Work Area

If your permanent darkroom site is a relatively small one, you will have to perform certain processing functions (such as washing and drying your prints) somewhere else. Keep in mind that convenient layout and good workspace are more important than room size, and plan accordingly. Store paper, focusing aids and other printing necessities under the counter your enlarger is on. If necessary, make a two-level wet area by placing the holding tray on a shelf under the processing tray area, as shown in the diagram.

General Considerations

When searching for a location, your main consideration will be the kind of space you have available. Several factors to keep in mind include size, lighttightness, lighting, ventilation, humidity, and temperature.

Size. The ideal darkroom would contain two large counters or work-tables, as well as plenty of room for shelves and cabinets for storing equipment and supplies. Don't despair if you don't have this much space; some professionals don't either. The minimum requirement is enough room for an enlarger and at least three 8″ x 10″ trays, plus a place to keep handy a box of printing paper, a timer, and a small numbr of accessories. Your storage areas can be outside the darkroom, and you can use wall brackets to create a good deal of vertical shelving in even a small working area.

Lighttightness. You must at least be able to make the room dark enough that you cannot see any light after two minutes. Obviously, this is most easily accomplished in a room with no windows, such as a closet, or in a room with only one or two small windows. And if you work only at night, the problem is further simplified. There are various methods for making a darkroom truly dark, and these will be discussed at the end of this chapter.

Electricity. It is desirable to have an overhead light socket and at least one double electrical outlet in your work area. It is best to use a separate outlet for each item that requires electricity; relying on one extension cord or a three-in-one plug to solve an electricity supply problem can be hazardous. And don't forget that you may want to provide for a radio in the room.

Ventilation. Protect yourself from chemical fumes by making sure there is adequate air circulation. Unfortunately, by shutting the light out of your darkroom, you close out much of the fresh air as well. Methods for providing an air supply are discussed at the end of the chapter.

Humidity. Dampness is harmful to equipment and supplies, especially film and printing paper. The best relative humidity is between 45 and 50 percent. You may need a dehumidifier if dampness is a problem (or a humidifier if the problem is dryness).

Temperature. The best darkroom working temperature is between 20 and 24 C (68-75 F). In some locations, such as attics, temperature extremes may be a problem.

Many photo stores sell a special, opaque cloth which is ideal for blacking off window light in areas intended for temporary darkroom use.

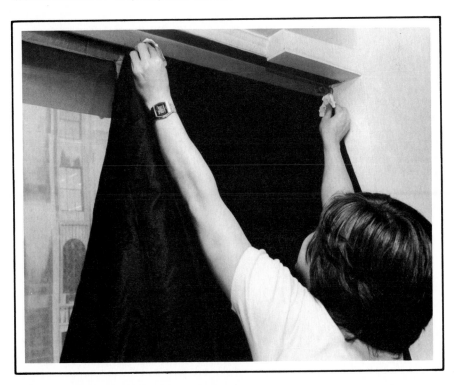

The Permanent Darkroom

Many locations, such as a spare room, basement, or garage, may be suitable, but each will have problems that must be solved. It is important to think through carefully what may be required. Here are some typical possibilities and the factors to consider:

Spare room. This is often your best bet. It probably has adequate electricity and working space and won't be too difficult to darken. It probably won't have running water, but, as noted before, this is not essential. In some cases, it may be possible to install plumbing.

Closet. If it is large, a closet should give you sufficient space, and it will almost certainly be the easiest location to make really dark. If the closet is small, you will have to decide whether the cramped conditions are worth the convenience of a permanent setup. In either case, there are likely to be problems with ventilation and electricity. If you work mainly at night, it may be possible to provide an air supply by darkening the room the closet opens into and leaving the door partially open, although you may have to curtain off the door with opaque material. Electricity problems will be tougher to solve. Many sizeable closets have an overhead light socket, but there may not be any outlets. Again, remember to be cautious about over-

A room reserved solely for photographic processing and printing is obviously more desirable and convenient than a temporary area. In a full-fledged, permanent darkroom you can install counters, shelving, and arrange the work areas to suit your needs exactly. You can also make use of large, extra sturdy enlargers that would be too heavy and bulky for convenient movement to and from a temporary darkroom area.

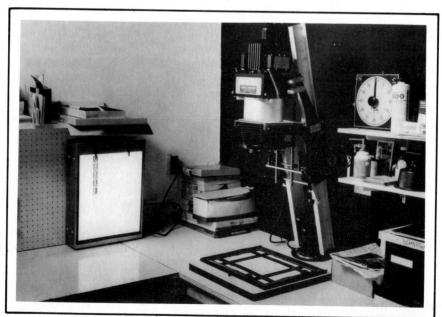

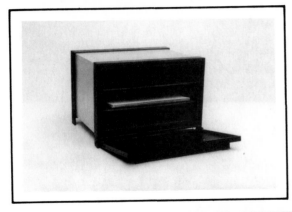

A well designed paper safe makes even the most efficiently laid out darkroom easier to work in. The shelves inside the safe let you store various grades or types of photographic paper in a lighttight and compact place.

Your darkroom sink should be big enough to accommodate at least three processing trays and a larger holding/washing tray. Note the splash board and storage areas built onto the sink shown.

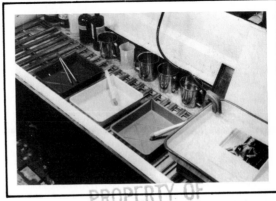

loading extension cords. If the space is otherwise suitable, it may be worthwhile to have a licensed electrician install outlets. Be sure the wiring meets applicable wiring and inspection codes.

Basement. Here you will certainly have enough space, and there may well be outlets as well. But humidity may be a problem in summer, for which you will need a dehumidifier. If there is a furnace in the basement, you may encounter problems with heat and dryness during winter. For dryness, use a humidifier; to offset the heat factor set it up at some distance from the furnace. Or you may be able to work during periods when the furnace is not going full blast. Otherwise, consider another location.

Attic, garage, or shed. You may have trouble with temperature extremes in these locations—too hot in summer and too cold in winter. In addition, they may be without electricity. Such areas generally provide a lot of space, however, and you may wish to have electricity and insulation installed. Make sure that the electrical supply is adequate, and you can then plug in cooling and heating devices to handle the temperature.

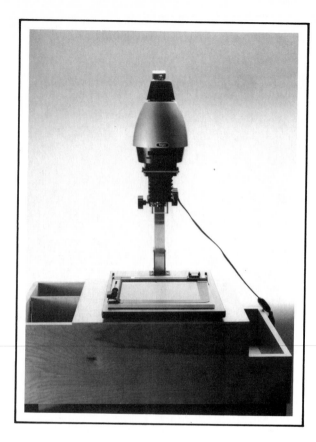

If your temporary darkroom area has limited counter space, put the enlarger on a solidly built cart. Make sure the cart has space for your paper and small printing aids. The enlarger cart will be even more convenient if you attach locking wheels to its legs.

The Temporary Darkroom

In many homes, it is easier to find a place for a temporary darkroom than for a permanent one. Because it is inconvenient and time-consuming to set up the darkroom before each printing session and dismantle it afterward, choose a space that will give you the maximum chance to work without interruption.

Here are the advantages and disadvantages of some possible locations:

Kitchen. If there are no major traffic problems, a kitchen may be your best bet. There is running water, and in a large kitchen there will not only be counter space, but room to set up at least one worktable. There will also be plenty of electricity, including a heavy-duty outlet. Even a small kitchen may be adequate. If there is no pilot light in your stove, you can cover the stove with a sheet of protective plywood of chipboard, and place the enlarger on top. Even a short counter may be enough to hold the minimum of three trays. However, to work in the kitchen you must have clean working habits.

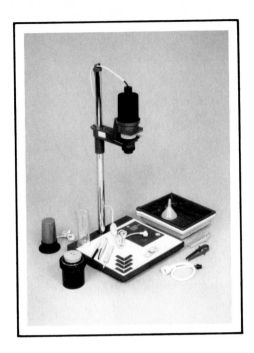

A number of companies produce compact, well designed beginners' darkroom kits that contain all of the basic tools needed for black and white enlarging. These kits are portable enough to be moved into a temporary darkroom area and set up in a matter of minutes.

Bathroom. Here, again, you have the advantage of running water, but getting enough privacy may be a problem. If this is not too great a problem, then the bathroom may be a possibility. There are other drawbacks, however. If you cover the bathtub with plywood to create working space, you will have to stoop and bend often. And while it is sometimes recommended that you leave part of the bathtub uncovered for catching chemical spills, these may cause undesirable stains in many tubs. If the bathroom floor is made of easy-to-clean tile, it may be better to keep the entire tub covered.

If you live in an apartment, your bathroom may be too small to hold a table for the enlarger. In some cases, you can place the enlarger on the panel covering the tub, but this must be safe and sturdy. Unless your bathroom is large enough for these difficulties to be minimized, use it only as a last resort.

Closet. Look elsewhere if using this space means clearing it of clothing and its usual contents each time you have to set up.

Bedroom. This may be a very good possibility. The room will have electrical outlets, and you can work out a schedule that gives you long, uninterrupted printing sessions. In fact, a bedroom, or any comparable space, may offer the opportunity for a "semi-permanent" darkroom—one that does not have to be completely dismantled after each use. You may well be able to set up a permanent working area within the bedroom, even though you only use it part of the time.

Setting Up

Think of your darkroom as requiring two distinct sections: dry and wet. The dry area is where you will place your enlarger, load the developing tank, and keep printing paper and accessories. The wet area is where you will lay out the chemical trays for processing, and will include the wash area, if this is located in the darkroom. Ideally, there will be a separate table or counter for each section. The storage areas for the materials used in each section should also be separate. Organize the room so that your work flows smoothly and efficiently.

Technique Tip: Organizing Your Darkroom

- Keep paper and accessories to the side of the enlarger opposite the wet area.
- Set up the enlarger near the processing trays so that the exposed printing paper can be slipped efficiently into the developer. Insert a panel between the enlarger and the trays to serve as a splash barrier.
- Make sure the enlarger has a sturdy support. Do not, for example, put it on a flimsy card table, because if the enlarger shakes, the print will not be sharp.
- Ground the enlarger by running a wire from the enlarger post to a cold-water pipe or other ground. This helps guard against static electricity, which draws dust to the negatives.
- Lay out the trays so that your processing steps move away from the enlarger, toward the wash area (or tray of water for collecting prints).

Safelights. Another important consideration in setting up the work area is to position the safelights carefully. A safelight is a hooded, low-wattage light with a filter. It enables you to see in the darkroom without fogging the printing paper.

Place a safelight with a maximum 15-watt bulb over the processing area so that it is at least four feet from the printing paper at all times. If your work area is large, it may be advisable to add a second light over the dry area. Since this is where your printing paper is stored, the bulb should be no more than 7½ watts.

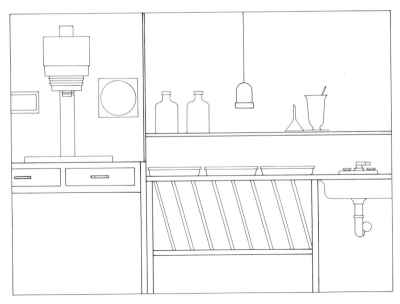

The dry area of your darkroom is where you will do most of the creative work—when you plan out the space, arrange everything in logical order and leave yourself plenty of work room. A cabinet underneath the enlarger would be the ideal place to store printing paper and small items such as canned air and dodging tools. The wet area should be carefully laid out also—most photographers prefer a left-to-right arrangement of processing trays, with the developer nearest the dry area and the washer furthest away. This arrangement allows you to move slowly through the exposure, development, fixing, and wash stages. Store all processing solutions underneath the sink in the wet area, and keep packaged chemicals as far away from the dry area as possible.

Even with these precautions, the safelight may still fog your printing paper. This fogging may be so slight that is is not readily noticeable, but it will nevertheless dull the highlights of your prints. You can determine if your safelight is truly safe by performing the following test:

1. In complete darkness, or with safelight moved or angled to give a minimum amount of light, take an unexposed piece of printing paper through the processing steps described in Chapter 6. This will give you a whiteness standard.
2. With the safelights on, in the normal position, place another piece of paper in an enlarging easel and place a coin on the emulsion. Leave it in place for five minutes for standard papers, three minutes for rapid papers.
3. Remove the coin and give the paper a quick flash of light with the enlarger. Experiment to determine how much of a flash is required; it should be just enough to give you a barely perceptible tonality when the paper is processed (compared to the paper you prepared as a standard).
4. Process the paper. If your safelight is safe, you will have a continuous tonality with no trace of the coin. If the outline of the coin is visible, you should reposition the safelights or use a lower-wattage bulb.

Make It Convenient

The smaller the setup, the more essential good organization becomes. If you are really cramped, make use of wall bracket shelving not only for storage, but for a vertical arrangement of processing trays as well. There are also commercially available "tray ladders" (metal frameworks holding standard-size trays) for just this purpose. If you do lay out your trays vertically, be extremely careful to avoid spilling chemicals into the tray below. To guard against developer contamination, it is best to put the developing tray on top and work downward.

Paper safes (lighttight boxes or cabinets) are very helpful in preventing paper fogging. You can construct one or purchase a unit from photography supply stores.

Commercially available darkroom sinks can serve as useful "wet" benches, even if the room has no running water. These have either a long, shallow sink alone, or a shallow area with a deep utility sink at the end. They make it easier to protect against spillage, and those with a deep area can provide a water holder for temporary print storage after processing.

Your darkroom need not be painted a dark color. If your safelight is safe enough, the reflectiveness of matte white walls, for example, can increase darkroom visibility. If there is a chance of light being reflected from the enlarger's lamphouse, then paint the area behind the enlarger a darker color.

Other space-saving items for storing accessories include pegboards with hooks and shoe bags with pouches. Kitchen spice shelves, either wood or wire, are also useful.

You can supply any darkroom with water by obtaining the type of water container used in camping. These come in several sizes, some equipped with spigots. The amount of water they can hold will not be sufficient for washing prints or negatives, but you will have enough water for diluting chemicals, rinsing prints and accessories when necessary, and for keeping your hands clean, which is also very important.

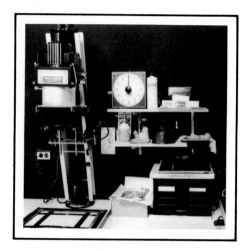

Increase the efficiency of your darkroom by keeping all necessary items neat and within easy reach. If you have a permanent setup, build some shelves near the enlarger, to keep such items as timers, focusing aids and dodging tools handy, yet out of the way.

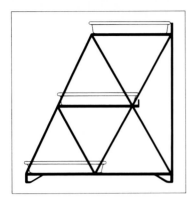

If you have extremely limited darkroom space, such as a spare closet, you might need to use a tray ladder, rather than a conventional wet-area table or sink. Tray ladders are metal or plastic frames specially designed to hold three processing trays, one atop the other. The trays are staggered, as shown in the diagram, to let you insert and remove your prints easily.

Keep It Clean

The two main cleanliness problems in the darkroom are dust and chemical splashes and spills. Dust on the negative results in white spots on the print, which must be "spotted" out (see Chapter 9). This is a tedious job and should soon teach you the advisability of keeping the working area as dust-free as possible.

Decorative curtains and carpets are potent dust sources and should not be used in permanent darkrooms. In a temporary space, however, you may have to tolerate them. If so, vacuum them frequently, along with other potential dust sources such as bookshelves or open storage areas.

Store equipment and supplies in cabinets rather than on open shelves. When shelves are required, keep them uncluttered to make them easier to clean and to minimize dust accumulation. Wiping worktables with a damp cloth before each printing session also helps alleviate the dust problem.

Chemical spills are inevitable from time to time, and even minor ones can stain or otherwise ruin many counter and floor materials. To prevent this, use a surface material made of vinyl, linoleum, or Formica for your wet table. If this is not feasible, rigid plastic panels and rubber or heavy plastic sheeting make good substitutes.

Solid vinyl or linoleum floor coverings are also recommended (cracks can be hard to clean in tiled floors). Unless these materials are textured, they will be slippery when wet and may even become electric shock hazards, so be careful. Chemical-resistant matting, which is ridged to lessen the danger of slipping, is available from industrial supply houses. It is also shock-absorbing and reduces the strain on your feet.

You may also find it necessary to put a protective covering on the wall behind the wet area. As already noted, a splash barrier between the enlarger and wet area is frequently required.

Give the darkroom, temporary or permanent, regular and thorough cleanings, including mopping if the floor material allows it. And clean up chemical spills promptly. When chemicals dry, they become powdery and add to the dust problem—in this case, a dust that can contaminate and ruin negatives and prints.

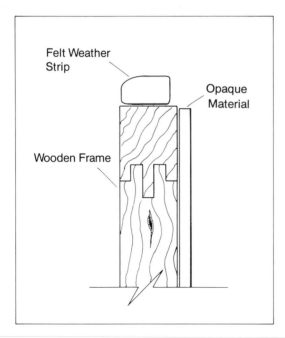

Felt Weather Strip

Opaque Material

Wooden Frame

If your permanent darkroom site has windows and you do not want to bother putting up opaque curtains each time you print, build yourself some blackout panels. Use completely opaque cloth or plasitc, stretched and fastened to a wooden frame that fits snugly inside the window space. As shown in the diagram, strips of felt will help ensure a snug fit.

Lighttightness

If you can't see anything after ten minutes, your darkroom is dark enough for most printing purposes. But for loading film into the developing tank, your standard must be more rigorous. In this case, you should be unable to see a white or hightly reflective object in the room after 15 minutes.

You can black out the darkroom in a number of ways, although your choices may be narrowed in a temporary setup by what the other members of the household will let you get away with. For example, the simplest way to block off windows is to tightly tape or tack opaque cloth, plastic sheeting, or cardboard to the window frame, although it can cause a lot of wear and tear to the woodwork if this is done repeatedly. If you do use this method, and work at night, it may suffice to attach the material only at the top of the window. Or you can tack Velcro fasteners over the window and sew or glue other such fasteners to the covering material for easier setting up.

Another possibility is to build a wooden frame, which fits snugly inside the window frame, and to attach to it a wooden or cardboard panel or some other opaque material. By wrapping felt around the edges and gluing or tacking it down, the frames can be put up and taken down whenever necessary without doing much damage.

In a permanent darkroom, you can seal off the windows completely by boarding them over or by replacing them with wooden panels. However, to

be able to let the light in at times, simply use one of the methods described above.

Doors are much less of a problem. If you work at night, and if the work area is not close to the door, you can block out a tiny crack of light by spreading a towel across the bottom of the door; other cracks can be taped over or stuffed with felt strips (weatherproofing is good for this). Sometimes it may be enough simply to darken the room into which the door leads.

In the daytime, or if more effective measures are required, attach a curtain rod over the door (make it wider than the door by at least a foot on either side) so that you can drape an opaque curtain across it.

Ventilation

Again, the problem is simplified if you work mostly at night. By covering the windows with plastic sheeting or cloth, you can leave the draping loose at the bottom and the window partly open. Also, if you can darken the adjoining room, you can leave the door partially open (you may have to curtain it off if there is still a chance of light coming through). Another alternative, if your budget and the nature of your room permit, is to install a lighttight ventilating fan.

If none of these methods are practical for your kind of setup, then avoid being shut up in the room for long periods; take frequent breaks, or open the door for several minutes at least every half hour. Leave the door open whenever you leave the darkroom to, say, take prints to an outside wash area. The problem of ventilation will be less acute in a large darkroom, but do not overlook the need for an adequate air supply.

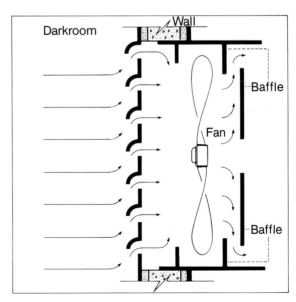

You will find film and paper processing much more pleasant in a well-ventilated darkroom. Shown here is a simplified cross section of an exhaust vent, used to remove processing fumes. One of these should be built into the wall of your permanent darkroom. Note the baffles that keep light from entering through the vent.

2

Making the Negative: Equipment and Chemicals

Equipment

You don't need a great deal of equipment for processing black-and-white film, and much of that is quite inexpensive. In fact, household items serve just as well as specially made equipment in many instances. When choosing a developing tank or thermometer, however, get the best you can afford to help guarantee consistency and accuracy. Good ones can last many years, a factor that offsets the extra cost.

Technique Tip: Necessary Film-Processing Equipment

- Developing tank
- Thermometer
- Timer or clock with sweep second hand
- Chemical storage containers
- Measuring graduates
- Plastic stirring rod
- Funnel
- Film cassette opener
- Scissors
- Rubber or plastic hose
- Film clips
- Sponge or squeegee (optional)
- Negative files or envelopes
- Changing bag (optional)

The tones in your negative are the opposite of those in the original scene—light subject areas appear as dense or dark negative sections; dark subject areas look thin, or clear, in the negative.

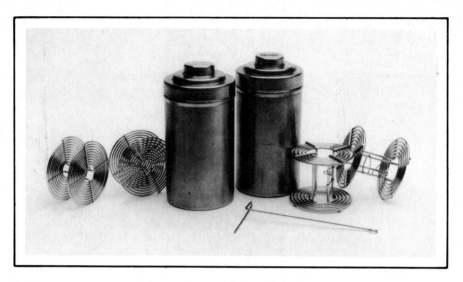

Stainless steel tanks and reels are easy to keep clean, sturdy, and allow easy control of processing solution temperatures. The steel rod pictured here fits through the center of the reels, and is used to quickly insert or remove processing reels into or from the tank.

Developing Tank and Thermometer

Developing tank. There are several models, made of plastic or stainless steel, that are designed especially for 35mm film. There is a light-safe opening in the lid, so that once the film is loaded, processing can be done with the lights on. The plastic tanks are the least expensive and are often the easiest to load, but they are also less durable and you must take greater care in keeping them clean to prevent contamination of chemicals.

Most tanks, plastic or steel, have spiral reels onto which the film is wound. Many plastic reels are self-loading, which means that once the film is secured to the outer rims, you simply turn the sides of the reel until the film is completely wound. Many plastic reels are also adjustable to accept different film sizes. Some plastic tanks have "aprons" (plastic strips with crinkled edges) instead of reels. The film is fitted onto the apron, which rolls up, and the raised edges of the apron allow the chemicals to reach the film. It can be tricky learning to fit the film correctly, however, and you must take special care to keep the aprons clean.

With stainless steel reels, the film must be attached to the center of the reel, then wound outward into the grooves. Again, this can be tricky for beginners, but it is not difficult to master with practice.

Because stainless steel is a better thermal conductor than plastic, the temperature inside a steel tank can be readily controlled by an external water bath (see Chapter 4).

Agitation is very important in processing, and it can be done more efficiently in some tanks than in others. Steel tanks and some plastic units have leakproof lids, and you can agitate the tank by turning it upside down (the most effective method). Some plastic tanks have a rod that extends through the center which you turn to rotate the reels. Both methods of agitation are possible with some tanks.

It is to your advantage to get a tank that will hold two 35mm reels. This will not only save a lot of time, but the tank will also hold a reel for 120-size film.

Whichever tank you choose, it is vital to keep it clean. Wash it thoroughly after each use, and allow it to dry completely before loading another roll of film.

Thermometer. Accurate temperatures are critical in film processing, so get a good thermometer. Two basic types are available: the dial top, which has a metal stem filled with alcohol; and the glass rod, which is filled with mercury. The dial-top thermometer is easier to read, more durable, and the ones made by Kodak, Beseler, and Weston are quite satisfactory. The best quality glass thermometers, such as the Kodak Color Thermometer, give the greatest accuracy and have the quickest response to temperature changes. However, take care they do not break and spill out the poisonous mercury. Avoid the cheap glass thermometers; they are neither accurate nor responsive enough.

An accurate thermometer is essential for efficient darkroom work. Dial type thermometers such as the one shown are durable and easy to read. The more expensive ones can be recalibrated, should they suffer a knock and become inaccurate.

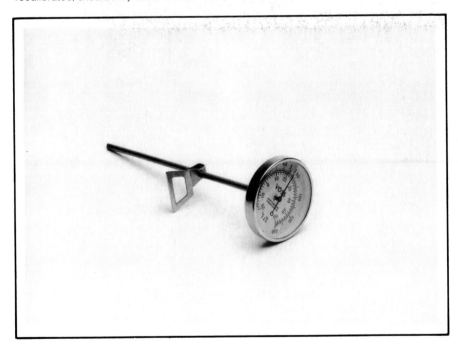

Other Basic Equipment

Timer or clock. You don't need a sophisticated timer for film processing. A clock with a sweep second hand is a good substitute. It is helpful if the clock has a light face with dark numbers and hands for easy reading. However, if you want to invest in a timer, note that the ones designed for enlarging often do not have a time range adequate for film processing, and those made for film development frequently do not have the proper time settings for enlarging. Timers that provide both features are quite expensive.

Chemical storage containers. Plastic containers specially made for photographic chemicals are very convenient and are readily available at little expense. Some are collapsible; they can be pressed down as the chemicals are used up, thereby squeezing out the air. Since the chemicals, the developer in particular, are subject to oxidation, this is very helpful, especially if solutions are used infrequently. A variation on this is a cardboard cube with a refillable plastic bag inside that collapses as the chemicals are poured out (through a spigot).

Glass juice bottles are also good for storing chemicals. Dark-colored bottles (or bottles that have been spray-painted black) are preferable, especially for the developer, to avoid light-caused deterioration to the chemicals. Be careful when storing fixer in such jars as the solution tends to corrode the lids.

(Below left) Specially designed photographic timers make work easier in the darkroom. The most convenient types have large, luminous dials with separate sweep hands that count minutes and seconds, and provide a means to automatically turn off the safelight while exposures are being made. Opaque plastic chemical storage bottles (below right) are inexpensive and shatterproof. They provide a neat and efficient way to store your processing solutions.

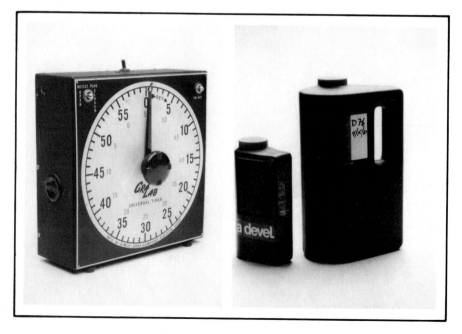

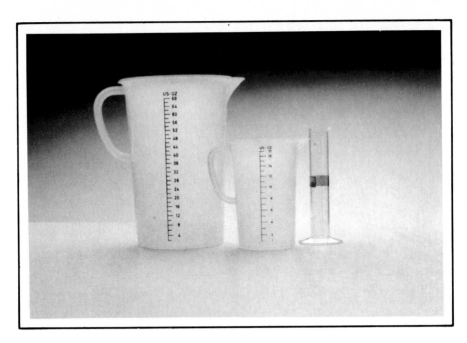

Measuring beakers and graduates such as those shown above are marked in both avoirdupois and metric gradations. They make chemical mixing easy and efficient.

Whether plastic or glass, use each container for only one kind of chemical to prevent contamination. Label each one carefully with the name of the chemical, the dilution, the date mixed, and the number of times used. Also put the name of the chemical on the lid. If you use juice jars, make sure to remove the original labels so that no mistake will be made about their contents. Photographic chemicals are poisonous, so be careful about keeping them safely stored.

Measuring graduates. You need these for measuring the amount of chemicals to be poured into the developing tank. It is an advantage to have at least three for film processing, so that the different solutions can be kept ready for immediate use. The plastic darkroom graduates sold in photography supply stores are excellent and inexpensive. The 500ml (16 oz.) size is best for two-reel developing tanks. With larger sizes, it is more difficult to measure the precise quantities when diluting the developer or liquid concentrates, if they are being used.

Clean plastic graduates promptly after each use, and do not leave chemicals standing in them longer than necessary. Glass graduates are more expensive but are easier to clean. Kitchen measuring cups can be used if necessary (the large, batter-bowl type is convenient for chemical mixing), but be careful, as it is usually more difficult to make precise measurements with them, and they are often inaccurately marked.

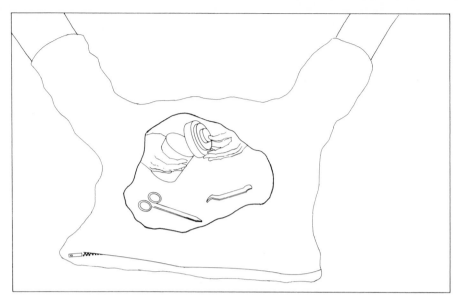

If none of the rooms in your house can be made dark enough to safely load your film onto processing reels, buy a changing bag. This rubberized cloth item is completely lighttight, and large enough to hold your film, tank, reels, and other useful items such as scissors and a bottle-opener. The elasticized sleeves let you insert your hands for loading, as shown, without letting any light in.

Accessories

Stirring rod. Glass stirring rods are excellent for mixing chemicals, but the plastic paddle type is all you need if you keep it clean. Do not use household instruments, such as wooden stirring spoons, because of the health risk from chemical contamination.

Funnel. A funnel is very helpful when pouring chemicals into storage bottles. Spills are wasteful, and cleaning them is time-consuming. Some funnels have a stainless steel mesh filter, which helps in removing dirt or undissolved particles form the chemicals.

Film cassette opener/scissors. A couple of household items will make it much simpler to get the film into the developing tank. Use an ordinary bottle opener or a pair of pliers to pry off the end of the film cassette. Use the scissors to snip off the thin leader strip from the end of the film, and to cut off the tape holding the film to the spool.

Rubber or plastic hose. A small hose that can be attached to a faucet and run through the center of the reels in the opened developing tank facilitates film washing (see Chapter 3). A handy item for this procedure is the rubber hose–spray nozzle combination sold in variety and drug stores for hair washing. Remove the nozzle from the end, and you have a hose already designed at the other end to fit onto most faucets.

Film clips. There are several varieties of plastic or metal clips for hanging wet film up to dry. You need two for each roll of film: one with a hook for hanging the film onto a line, and a weighted clip for the bottom end so that the film will not curl as it dries.

Sponge or squeegee. If film is hung up to dry as soon as it is washed, water spots will form. One way to prevent this is to first remove excess water, and many photographers accomplish this simply by running the film lightly through two fingers. Others use a photographic sponge or a squeegee (wipers made of rubber blades or small sponges). Either method may result in scratches on the film. Moreover, sponges or squeegees must be kept very clean. The best way to prevent water spots is to use a wetting agent (described in the "Chemicals" section of this chapter). If you do use a sponge or squeegee, use it only for film.

Negative files or envelopes. Once the film dries, you will need some method of storing it. One way is with negative files—plastic sheets with pockets for negative strips. These often come with holes along the side for storing in binders. Another way is to store the negatives in glassine envelopes. For permanent storage, however, the plastic sheets are preferable to glassine envelopes, as the sulphur content of the envelopes will eventually damage the negatives.

Changing bag. This is necessary only if you cannot make your darkroom (or any other room) absolutely dark for loading film into the developing tank. Be sure to practice working in a changing bag before loading a roll of exposed film.

Film drying clips come in a number of shapes and sizes. For all intents and purposes, most of them are variations on the clothespin, which works quite well as a film drying clip.

Chemicals

Two basic chemicals are required for making a negative: the developer for bringing out the image, and the fixer to preserve it. Other chemicals are not essential, but they do make the process easier and much more efficient.

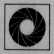

Technique Tip: Film-Processing Chemicals

These are the chemicals you will need for developing film, in the order of their use in processing:
- Developer
- Stop bath
- Fixer
- Washing aid
- Wetting agent

Developer. There are many developers on the market, and you must understand how they differ in order to choose the one that gives you the results you want. The following is a guide to the main types.

General purpose. These developers give a full tonal range and are designed to give the best combination of grain control, sharpness, contrast, and film speed. They are recommended if your photography covers a variety of subject matter under different lighting conditions. Good general-purpose developers include Kodak D-76, Ilford ID-11 Plus and Ilfosol 2, Paterson Aculux, and Edwal FG-7. These are excellent for medium- to high-speed films such as Kodak Plus-X and Tri-X, Ilford FP4 and HP5, and Agfa Agfapan 100 and 400.

Fine grain. The developers in this category reduce the graininess of the negative, usually at the price of a slight loss of effective film speed and contrast. Good fine-grain developers include Kodak Microdol-X, Ilford Perceptol, and Edwal Super 20. Used in combination with slow- to medium-speed films (Kodak Panatomic-X and Plus-X, Ilford Pan F and FP4, Agfa Agfapan 25 and 100, for example) they yield negatives that allow large blowups with minimum grain. In addition, they help compensate for the tendency of some slow films to have higher than normal contrast, and they are useful in instances where slightly reduced contrast is desired. They can also help compensate for overexposure.

High energy. These developers are formulated to increase effective film speed; that is, to allow film to be shot with less than the normal exposure for its ISO/ASA rating. Graininess and contrast are also increased

Photographic chemicals come in powdered or liquid form. Shown here from left to right are these fundamental processing chemicals: Dektol, a developer used mainly with photographic papers; stop bath, used to arrest the developing action; and a fixer, which removes unexposed silver salts from the emulsion and allows the developed image to be safely exposed to light.

in some cases, and the shorter development times recommended for these developers give less control and less tolerance for timing error. These developers are useful for low-light shooting, and they help compensate for underexposed film. Good high-energy developers include Acufine, Agfa Rodinal, Ethol Blue, and Ilford Microphen.

Making your choice. Consider the characteristics of the different kinds of developers careully, and evaluate them according to your needs. If you do most of your shooting with the camera on a tripod, and make very large enlargements, you will undoubtedly want to use a slow film, fine-grain developer combination. In most cases, however, it is a good idea to start out with a good general-purpose developer in combination with a standard medium-to-high speed film. There are several reasons for this:

1. These combinations give good, reliable results for most shooting situations.
2. Becoming thoroughly acquainted with basic combinations like these will give you a standard for later variations you may need or simply wish, to try.
3. Standardization is always helpful in the beginning, because if something does go wrong during processing, it is easier to track down the problem.

Powdered vs. Liquid Developers

Some developers are available in powdered form, others as a liquid concentrate. Both types are quite economical to use in the small quantities required for 35mm developing tanks, and there are excellent developers in each category.

Powdered developers. You must prepare a stock solution by dissolving the powder in water. Since the water used must be quite warm, the solution has to be prepared in advance of its actual use. Otherwise, it can be a tricky matter to get it to the right temperature for processing. You can use the stock solution at full strength to develop numerous rolls of film, and maintain strength by periodically adding a replenishing solution. However, the stock solution of these developers can be further diluted with water to make a "one-shot" working solution, which you use one time and then discard.

1. Since the dilution is discarded after use, there is no danger of the solution not being at its full working strength. This in turn helps guarantee consistency of results.
2. Image resolution is increased, giving greater apparent sharpness to the picture.
3. Developing time is increased, which makes it easier to maintain control over development, since the effects of timing errors are reduced.
4. It is easy to bring the dilution to the proper processing temperature by controlling the temperature of the water that is added.

One disadvantage of powdered developers is the somewhat limited shelf life of the stock solutions made from them. This is a factor to consider if you develop film only occasionally, but it can be offset if you buy only in small quantities and if you use the stock solutions for one-shots and then discard.

If you use the stock solution at full strength, be sure to keep it correctly replenished. In most cases, you will need to add replenisher after each 36-exposure roll of 35mm film has been processed. Pour the required amount of replenisher solution into the bottle of stock solution before you pour in the developer from the developing tank. If there is any remaining solution in the tank when the bottle is filled, discard it.

Liquid concentrates. These are easier to use than powdered developers. Liquid concentrates are themselves stock solutions, therefore no advance preparation is required. Since they are usually used as highly diluted one-shots, full working strength and consistency of results are almost guaranteed if the solution is fresh. Temperature control is easily maintained by dilution. Liquid concentrates also have a longer shelf life, making storage and infrequent processing less of a problem.

Stop Bath and Fixer

Stop Bath. At its proper working strength, a stop bath is a weak acid solution that neutralizes the alkaline developer and stops the developing action. The stop bath also extends the life of the fixer by preventing its contamination by the developer.

The most commonly used stop bath preparations are a 28 percent acetic acid solution and the "indicator" stop bath (which also contains acetic acid); both are concentrations that are highly diluted with water before use. One aspect of the indicator stop bath is that it turns a purplish color to signal when it has lost its effective strength. This is a dubious advantage, however, since the solution should not be used to this degree of exhaustion. It is preferable to use the plain acetic acid dilution, keep track of the number of film rolls processed, and discard the solution *before* the recommended limit is reached. Glacial acetic acid, which is an almost pure concentration, is also available. It requires two dilutions before it can be used; one to bring it down to the 28 percent level, and another to reduce it to working strength.

Acetic acid concentrations, especially the glacial type, must be handled with special care. They are poisonous, have noxious fumes, and can burn the skin. When diluting, always pour the acid into the water, *not* the other way around, as a precaution against boiling (again, most likely with the glacial concentration) and splattering. Label stock solutions as poison and store them safely.

Fixer. The fixing bath contains the "hypo," which makes the film image permanent. It dissolves any unexposed and undeveloped (thus still light-sensitive) silver halide crystals into a soluble compound that can be washed away. Most fixers also contain a hardening agent, which is important in film processing because it makes the negatives less susceptible to blistering and scratching.

There are two general types of fixers: standard, which contains sodium thiosulfate as the active fixing ingredient, and rapid, which contains ammonium thiosulfate. The film must be immersed (with appropriate agitation) in most standard fixers for five to ten minutes, and in most rapid fixers for two to four minutes (some require only a minute).

Rapid fixers can be valuable time-savers, but they must be used carefully since it is important not to overfix film. Doing so can cause too much silver to be dissolved, with a resulting loss of shadow detail. Prolonged fixing also makes it more difficult to wash the fixer out of the film, with the possible consequence of stained and fading negatives. At the same time, insufficient fixing will also result in staining and image deterioration.

There are "hypo-test" fluids available that tell you when the fixer is becoming exhausted; a drop of the test fluid causes a milky white reaction in the fixer if it is too weak. But you should not use the fixing bath until this point is reached. Again, the best method is to keep count of the amount of film that has passed through the fixer, and discard the solution before it reaches the manufacturer's recommended limit. It is also a good idea to prepare one fixing solution for films and a separate one for papers.

Washing Aids. When the film is adequately fixed, it can be exposed to light without risk, but it must still be washed to remove all traces of the fixer and its by-products. It is not as difficult to wash chemicals out of films as it is out of some printing papers, but the washing must be thorough for your negatives to have maximum permanence.

A washing aid (also known as a hypo eliminator or neutralizer) helps clear the fixer from the film and makes the washing process much more efficient than if water alone is used. Your washing time will be reduced dramatically when you use such a product, and you will conserve water as well. For best results, rinse the film before applying the washing aid. Wash for at least ten minutes (in a running water wash) after using the washing aid, regardless of manufacturers instructions, if you want to be assured of true negative permanence.

Washing aids are available in powdered and liquid forms, both of which are excellent. The powdered forms are cheaper, but the cost factor is negligible and the liquid concentrates are easier to use.

Wetting Agent. You learned earlier that excess water must be removed from the negative after washing to avoid water spots, and that there is a risk of scratches if a sponge or squeegee is used to do the job. This risk can be eliminated if a wetting agent is applied to the film after it has been washed. The wetting agent causes the water to run off the film smoothly, and no wiping is required. If distilled water is used in preparing the wetting agent, it also serves as a final rinse to rid the film of any deposits or sediment that might be sticking to it. After the film has soaked in the wetting agent for the recommended time, hang it up to dry.

You do not have to follow the manufacturer's instructions to the letter when preparing the wetting agent. Do not dilute excessively, but usually you can get away with one-half to two-thirds of the recommended working strength. Both Kodak and Edwal make concentrates that are very effective.

Water. Water is used in the preparation of every solution used for film processing and print-making, and usually the water can be taken straight from the tap with no problems. In some cases, however, the mineral content may be so pronounced that deposits form on the film, or there may be sulphur or even sediment in the water. If such problems occur, attach a filter to the faucet or use distilled water to prepare stock solutions and dilutions.

Storage. The shelf life of photographic chemicals is limited, and the manner in which they are stored can make a significant difference. Undiluted liquid concentrate developers can keep for up to a year, but unused stock solutions made from powdered developers usually keep for about half that time, or less. Their shelf life is reduced drastically when they are

used regularly or if they are kept in partially full containers. In these cases, their shelf life is reduced to six weeks to two months.

Oxidation is a great enemy of developers, and there are various methods of coping with it: by using compressible or collapsible plastic storage containers; by transferring solutions to smaller containers as they are depleted; or by adding clean marbles to the containers holding the solutions to displace the air.

Stop baths will keep for a very long time, but fixers and washing aids have a short shelf life—as little as two months in a tightly capped container for fixer, and three months for some washing aids.

Again, liquid concentrates keep better than stock solutions made from powders. With all chemicals, remember that freshness is necessary for proper processing, so do not use out-of-date solutions. If you develop film infrequently, do not prepare large quantities of stock solutions.

Do not allow chemical solutions to get too hot or too cold. The best storage temperatures are between 18 and 24 C (65 and 75 F). In a storage area that is below, say, 7 C (45 F), crystallization may occur. On the other hand, very high temperatures will further reduce the usable life of a solution.

This concertina-like item is a photographic chemical container, specially designed to collapse to a smaller size as the chemicals get used up. The oxygen in air weakens and eventually exhausts photographic chemicals such as developers and hypo neutralizers. This type of container will keep oxidation to a minimum.

3

Making the Negative: Processing

Exposure. For best results when printing, you must first have a properly exposed film, one that has been given at least the minimum exposure necessary for adequate shadow detail. Moderate overexposure is usally less detrimental than underexposure: If there is no shadow detail at all, nothing can be done at the developing stage to put it in, and portions of the negative will be completely transparent and will print as pure black.

Time and temperature. The length of development (with proper agitation) and the temperature of the developer are the determining factors in controlling development. Although there is a slight margin of error in any of these factors, accuracy in each is very important.

If the film has been correctly exposed, the best time/temperature combination will be very close to that recommended by film or developer manufacturer. But remember that these are not absolute rules, and sometimes you will need to make adjustments in order to get the best negative. Proceed carefully, however, if you decide to change either the standard time or temperature, and be prepared for much trial and error.

A properly exposed and developed negative contains full detail in both shadow areas and highlights (the most transparent and most dense areas of the negative), and will print best on "normal" grade paper.

Practice with a "dummy" or unexposed roll of film before you attempt to load your exposed film onto processing reels. Keep a firm but light touch on the edges of the film as you feed it into the reel—be careful not to let the film touch any surface from which it might pick up grit or dirt.

Preparation

Mixing the chemicals. Stock solutions are made from powdered chemicals by dissolving the powder in water that is often as warm as 52 C (125 F). Be sure the water temperature is the one specified in the instructions on the package; if it is too low, the chemicals will not dissolve properly. Add the powder to the water slowly. This will not only make it easier to dissolve, but will also help prevent clouds of chemical dust from rising into the air. Stir continuously, but not forcefully, until the powder is completely dissolved. Stirring too vigorously will bring air into the solution and promote oxidation, which is especially harmful to developers.

If lumps form when the powder is poured into the water, break them up with the stirring rod. This is important since undissolved particles can cause trouble if they get into the developing tank. The particles could rest against the film, causing uneven development or fixing, or they could suddenly break up and dissolve during agitation, making the solution stronger than desired. If necessary, use a funnel with a mesh filter to keep these particles out when pouring solutions into storage containers. It is also a good idea to shake containers before using the stock solutions or diluting them to working strength.

If you use the same mixing bowl for all chemical preparation, mix the chemicals in the order they will be used, and wash and rinse the bowl thoroughly after each use. Clean the funnel, stirring rod, and thermometer as well. Store mixing bowls and graduates upside down to keep out dust.

Read and follow the instructions that accompany the chemicals. Use the recommended amounts of water to prepare stock solutions and to dilute them to working strength, otherwise the chemicals will not behave as expected during processing. Also heed any precautions that are advised in handling the chemicals. Wear rubber gloves, if necessary, to protect your skin.

Loading the tank. Before you begin your first developing session, sacrifice an unexposed roll of film and practice loading the developing tank's spiral reel or plastic apron. Do this first with the lights on to get a feel for the different factors involved, then practice it in darkness. Repeat the procedure until you can do it smoothly and easily.

 ### *Technique Tip: Loading the Developing Tank*

1. Open the flat end of the film cassette and snip off the narrow leader strip.
2. If you are loading steel reels, attach the end of the film to the center clip of the reel.
3. Hold the film (touching only the edges) by gently pressing on the edges so that the film curves slightly as you guide it into the grooves.
4. Keep the hand holding the film as close to the reel as possible. With the other hand, smoothly rotate the reel (it may be helpful to rest it on a counter while doing this) and let the film be pulled into the grooves.
5. When you reach the end of the roll, cut the film as close as possible to the tape that holds it to the spool.
6. With a plastic reel, align the film under the flanges on the outer edge of the reel, and rotate the sides of the reel back and forth until the film is taken up. Both steel and plastic reels should be dry, of course, but this is critical with the plastic type since moisture can swell the film emulsion enough to make loading quite difficult.
7. When the reels are loaded, place them into the tank and put on the lighttight lid. If only one roll of film is being developed in a two-reel tank, place the reel containing the film on the bottom and the empty reel on top of it.

Temperature Control

The traditionally recommended processing temperature of 20C (68F) permits a reasonable length of development and effective chemical action in the different solutions used in processing. However, as you can see from the data sheets of most films, processing with most developers is possible in temperatures ranging from 18 to 24C (65-75F), with appropriate time adjustments. At lower temperatures, chemical activity is slowed down too much and effective washing takes much longer. At higher temperatures, developing times are too short and there is a risk of overfixing.

It is important to have the temperature consistent throughout processing. Keep the temperature of solutions and water within two degrees over or under the developer temperature, with no more than a two-degree variation when going from one processing step to the next. Film emulsion swells when it absorbs moisture, and the amount of swelling is dependent on temperature. If temperature changes are too great, there will be too much swelling and contraction. The result will be increased graininess, or even "reticulation" (a cracking of the emulsion) in extreme cases.

If you can keep the temperature of your darkroom within the recommended range, temperature control is further simplified, because you can choose the listing on the data sheet that is closest to room temperature. Liquid concentrates, or stock solutions that have been prepared at least several hours in advance will already be at room temperature, and all you have to control is the water used for dilution and washing.

Maintaining water temperatures may be more difficult than you think, however. Preparing dilutions is no problem, since you can alternate warm and cool water until the temperature is right, but washing the film in running water is another matter. In most homes and apartments, the water pressure, and therefore the amount of hot or cold water coming through the tap, may change each time a toilet is flushed or water is used elsewhere in the building. This can be disastrous, since a sudden surge of hot water can cause reticulation or even cause the emulsion to blister and peel.

Remember that you can reduce washing times considerably by using a washing aid. And during the short wash period involved, you can simply make sure no other water is being used. Or you can constantly check water temperature and pull the hose or tank away if a change occurs. If the problem is really serious, you can fill a large container with water at the proper temperature and use it as a source of wash water.

If your darkroom temperature is not suitable, or if solution temperatures must be changed, there are several ways to make the proper adjustments:

1. Use liquid concentrates or diluted stock solutions whenever possible so that you can correct temperatures simply by adding water.

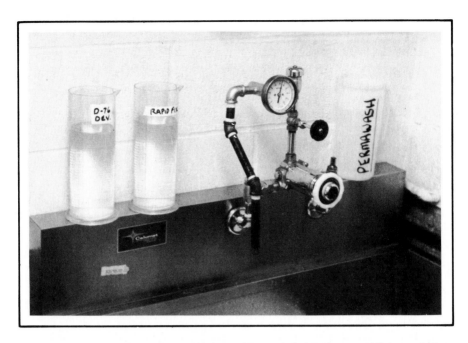

If you have erratic hot and cold water flow, equip your darkroom faucets with a temperature control valve, such as the one shown. This item will make it far easier for you to monitor and control the temperature of your wash water, reducing the risk of reticulation.

2. Set up a water bath. Have water at the required temperature standing in, or running into, a sink, pan, or tray, and place storage containers into the bath in advance of processing to bring the solutions to the required temperatures. Also keep the developing tank in the bath as much as possible during processing for maximum control (Keep the water below the lid because not all tanks are completely leakproof). Monitor the water bath temperature. If it is a running water bath, be alert for surges of hot or cold water; if it is a standing bath, it will gradually become too warm or too cool, and you must add water to compensate.

3. Presoak the film. Before developing, pour water at the proper processing temperature into the developing tank. Tap the tank firmly against a hard surface to dislodge air bubbles. Pour out after one minute. This not only guarantees that the film will be at the right temperature at the start of processing, but also that the metal tank (if one is used) will not warm or cool the developer when it is poured in.

4. Allow time for cooling in the refrigerator for stock solutions that are too warm, if they are to be used without dilution. The solutions will continue to cool for a while after they are taken out of the refrigerator, you should remove them a little before they have reached the desired temperature.

Processing the Film, Step by Step

Step 1: Getting Ready. Make sure everything is ready for convenient and efficient processing. Here is a checklist to follow:

Technique Tip: Preparation Checklist

1. Developing tank is loaded. If one roll of film is being processed in a two-reel tank, both reels are in the tank with the loaded one on the bottom.
2. Chemicals are at the right temperatures and are standing by in graduates in the proper amounts and dilutions. The proper amount for a two-reel tank is 500ml (16 oz). Use the full amount even if only one roll of film is being developed.
3. The water bath, if required, is set up with a thermometer ready for monitoring temperature. If the thermometer is used to check chemical temperatures as well, be sure to clean it after each such use.
4. Your timer, watch, or clock is located for easy viewing. If you are using a watch or clock, calculate and make a note of the time development will end. This will avoid a timing error if you forget the precise starting time.

Step 2: Presoaking. Presoak the film in the following manner:

1. Pour water at the temperature you will use for developing into the developing tank.
2. Tap the tank firmly against a hard surface to dislodge air bubbles.
3. Leave the film immersed for one minute, then pour the water out. Do this just before pouring in the developer.

 The presoak not only aids in temperature control, but also promotes even and efficient developer action and reduces the chance of air bubbles at the beginning of processing.

Step 3: Developing.

1. Pour the developer into the tank quickly but smoothly.
2. Start timing as soon as pouring starts.

3. When pouring is completed (do not fill the tank so that it overflows), put the cap on the lid and tap the bottom of the tank gently against a hard surface to dislodge any air bubbles (which can cause undeveloped spots on the negative). Tilting the tank when you first start pouring can also lessen the chance of air bubbles.
4. Set the tank down (into a water bath, if you are using one, without letting the water reach the lid).

Follow the agitation instructions on the film's data sheet. Typical instructions call for agitation every 30 seconds for small tanks (which include the two-reel tank). If your tank has a leakproof lid, the best agitation method is to gently turn the tank upside down twice, with a smooth, rolling action of the wrist.

With plastic tanks that have a center agitating rod, give the rod five complete turns (one per second). It is also a good idea to rock the tank a little or slide it back and forth over a small area while agitating.

Step 4: Stopping development. At the moment the developing time is over, pour out the developer smoothly and quickly (into the sink for a one-shot developer, or through a funnel back into the storage container). Pour the stop bath or water rinse into the tank immediately and agitate for 30 seconds.

Step 5: Fixing. At the end of the 30 seconds, pour the stop bath or water rinse out and immediately pour the fixer into the tank. Agitate for 30 seconds when the fixer is first poured, and for 10 seconds (or four inversions) after each additional minute. Carefully follow the manufacturer's instructions about length of fixing, especially if you are using rapid fixer.

For best results, keep your agitation movements as consistent as possible. Follow the film manufacturer's instructions regarding agitation times, and avoid agitating too vigorously. For tanks with leakproof lids, use a gentle roll of the wrist while inverting the tank.

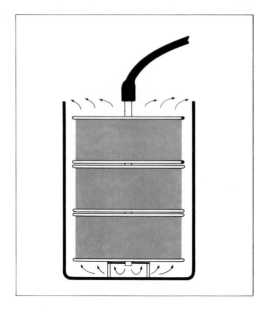

To increase wash effectiveness, run a hose through the center of your film reels so that the surging water will force settled fixer and other by-products up from the bottom of the tank.

Washing and Drying

Step 6: Clearing the Fixer.

1. When fixing is complete, pour the fixing bath back into its container.
2. Take the lid off the tank and rinse the film for 30 seconds in running water, or fill the tank with water and empty it two or three times. Also rinse off the lid of the developing tank.
3. Fill the tank with a washing aid and keep the film immersed, with gentle agitation, for at least the time recommended by the manufacturer.

Step 7: Washing. There are several methods for washing the film effectively. The least effective, though often used method, is to place the open developing tank under the faucet and let water splash down into it. Since the hypo in the fixer is heavier than water, it settles on the bottom of the tank, and water coming into the top may not get rid of it adequately. If you do use this method, pour the water out of the tank at one-minute intervals, and wash for at least 20 minutes (10 if you use a washing aid).

A much better method is to attach a plastic or rubber hose to the faucet and run the hose through the center of the reels to the bottom of the tank. This forces the water, with the hypo, to rise from the bottom and over the sides. Wash for 20 to 30 minutes (half that time if you use a washing aid). Even with a washing aid, wash for at least ten minutes to guarantee permanence for the negatives. Tap the tank occasionally to dislodge air bub-

bles. To really ensure negative permanence, pour the water out of the tank from time to time.

You can also wash the film effectively by changing the water in the tank often enough to eliminate all chemical traces. Here are two good ways of doing this: Let water run into the tank, agitate briefly, and pour the water out. Repeat this procedure 20 times (10 with a washing aid). Or put water into the tank, agitate for two to three minutes, and pour the water out. Repeat this ten times (five after using a washing aid).

If you are developing only one roll of film in a two-reel tank, place the loaded reel on top of the empty reel (the reverse of their position during the processing) before washing. This will make it easier to get rid of the fixer, especially in a running water wash.

The wash water temperature should be consistent with that of the processing chemicals. If the temperature of a running water wash cannot be brought close enough, change the temperature of the film in stages. Do this by soaking the film in successive water baths at temperatures three degrees warmer or cooler each time until the wash temperature is reached. Remember that water at less than 16 C (60 F) will require a longer wash period and that extremely warm water may damage the film emulsion.

Step 8: Preparing for Drying. Avoid water marks on the negative by using a wetting agent after washing so that the film will dry smoothly and evenly. Keep the film immersed in the wetting agent for about 30 seconds. Gentle agitation may sometimes help, but it is usually not necessary. Drain the film briefly and hang it up to dry.

An alternative to using a wetting agent is to wipe the film with a sponge or squeegee after washing. This is effective in eliminating excess water, but there is a risk of scratching the negatives. A sponge or squeegee must be kept thoroughly clean, and should be slightly damp when used. Dampen it with the wetting agent, if you are using both. In any case, wipe smoothly and gently, if you hear a humming sound, you are squeezing the film too hard.

Step 9: Drying. Using film clips, hang the film in as dust-free an area as possible; in other words, in a room where there is a minimum of coming and going. If doors are constantly being opened and shut, or if the film is hung near an open doorway, the air flow will deposit dust on the film.

The bathroom may be good as a hanging area, if traffic can be kept to a minimum for at least a couple of hours. (Film will take at least this long, and probably four or more hours to dry completely.) If the bathroom is suitable, stretch a cord (preferably plastic or nylon to keep shredded fibers off the film) across the top of the shower stall, close the curtain, and you have a nice drying chamber. If you are drying more than one roll of film, space them so that they do not touch each other or anything else. And be sure to keep your fingers off the negative area of the film.

Commercial drying units are also available. The least expensive of these usually consist of a plastic bag in which the film hangs, and there is often a blower attachment to circulate warm air.

Assessing the Negative

Evaluating a negative requires experience, although minor problems will be difficult to spot even to a practiced eye. But there is a rule-of-thumb method you can use to get a general idea of the quality of your negatives. In a "good" negative, you should be able to see detail in the shadow (most transparent) areas, but these areas should be only slightly more dense than the unexposed edges of the film. Also, you should be barely able to read newspaper or book print through the highlight (more nearly opaque) areas. (If you perform this test, do not let the film touch the newsprint.)

If you encounter any of the more common problems with your negatives, it may be difficult at first to tell whether they were caused by incorrect exposure or improper processing. If the trouble exists in only a few negatives on a roll, it is probably due to careless exposure. Under- or overdevelopment will show up on the entire roll of film.

Deal with development problems by being more careful about timing and about getting (and keeping) the temperature right. It may be that your thermometer is inaccurate; if possible, check it against another one at a camera store, and get a new one if yours is off.

If your processing procedures are correct, and you still have a problem with an entire roll, then something was wrong when you took the pictures.

Technique Tip: Common Problems With Negatives

If there are extreme problems with the negatives, they will be quite noticeable. Here are some that are most likely to occur:

- Too little exposure. This will result in a negative that is very thin and has little or no shadow detail.
- Too little development. The negative will be too thin, but it will have at least some detail. Underdevelopment occurs if developing times are too short, or if the developer is too cold. If development also looks uneven, there may have been insufficient agitation.
- Too much exposure. This will show up as a negative that is very dense over its entire area.
- Too much development. The negative will be quite dense but will still have detail, at least in the shadow areas. Highlights are likely to be blocked—so dense that printing them is very difficult, if not impossible. Overdevelopment results from developing times that are too long, or a developer that is too warm. Excessive agitation can also be a factor. Overdevelopment will also show up as increased graininess when an enlargement is made.

In a properly exposed but over developed negative (such as this one) dark, middle and light toned areas have poor detail and separation. Negatives that were incorrectly exposed and/or developed will exhibit flaws as described in the technique tip, opposite.

Perhaps you used an incorrect ISO/ASA setting, or perhaps there is something wrong with your camera's metering or exposure system.

If you are convinced that your film is properly exposed and developed, but your negatives are consistently a little too thin or too dense for normal printing, make an adjustment in your processing procedures. The best way is by slightly extending or shortening developing times, since timing is the factor that is easiest to control. Experimentation will be necessary, and the best way to do it is to shoot a roll of film for test purposes.

Expose the film by shooting normal subject matter under normal lighting conditions. If previous negatives were too thin and flat, increase development time by 25 percent; if the negatives were too dense, reduce development time by 25 percent. If the results are still not to your liking, modify these times until you get what you want.

For storage, for easier handling at the enlarger, cut the dried film into strips of six or five frames each, depending on whether you shot a 36- or 20-exposure roll. Strips of these sizes will fit into plastic negative files or into glassine or paper envelopes. The negative files are the safest way of storing negatives; they are also the handiest since they can be kept in ring binders. The envelopes will suffice for temporary storage, but they often contain harmful chemicals or have glue at their seams, which will harm the negatives in the long run.

Dampness, heat, and light can all cause negative deterioration, so keep the files or envelopes in a place that is dry and dark, and keep the temperature between 18 and 21 C (65–70 F) if possible.

Chromogenic Films

A new type of black-and-white negative film requires different processing than conventional emulsions. The new films have *chromogenic* emulsions which produce a negative image composed of a dye instead of black grains of silver. In fact, they are like color negative films and require the same processing. The major difference is that the dye image is black and gray, not variegated, and the negative does not have the overall orange-brown appearance that color films have.

At present there are two chromogenic black-and-white films: Ilford XP1, and Agfapan Vario-XL Professional. Currently, these are more expensive to buy and process than silver-image film, but they offer some definite benefits.

What they do. In comparison with conventional medium-to-fast films, those in the ISO/ASA 125–400 range, the new films offer three distinct advantages: finer grain; an extended tonal range, which helps control high-contrast subjects; and an expanded exposure latitude, which (since there is a standard developing time) lets you shoot a single roll of film at different ISO/ASA ratings.

In fact, the chromogenic films might also be called variable-speed films. Ilford, for example, recommends that XP1 film be exposed at ISO/ASA 400 for normal-contrast subjects. This will yield a "normal" negative in terms of contrast, but one with finer grain and a greater tonal range than you would get with a standard ISO/ASA 400 film. If the subject contrast is high, it is recommended that you shoot at ISO/ASA 200, or even 100, and the contrast will be reduced to a more easily printable range of tones in the negative—with a bonus of even finer grain.

Underexposure is more of a problem. In low-light situations, you can shoot at up to ISO/ASA 160 with XP1 or 3200 with Vario XL, but with a distinct increase in graininess and, at the highest end of the ISO/ASA range, a loss of shadow detail.

Agfapan Vario-XL professional film has a basic speed of ISO/ASA 125, but can be rated at speeds up to 1600 without any change in processing.

Processing. With conventional black-and-white films, the silver halides in the emulsion are converted to metallic silver deposits by the exposure/development process. But with the chromogenic films, *all* silver is eliminated during processing. Thus it is not surprising that the standard black-and-white processing chemicals cannot be used. Instead, for home processing in daylight tanks, you can use Kodak C-41 color negative processing solutions, or processing kits offered by the manufacturers. In Ilford's case, this is the Ilford XP1 processing kit, which consists of three developer parts and two bleach-fix parts, all in the form of liquid concentrates. The Agfacolor Process F kit also consists of liquid concentrates,

and comes in three parts: developer, bleach-fix bath, and final (stabilization) bath.

There is a standard processing time for chromogenic films; there is also a standard processing temperature, which is much higher than that for standard films. There is also less margin for error, so correct timing is vital, and it is essential that a water bath be used to maintain the correct temperature.

As with other films, chromogenic films must be loaded into developing tanks in total darkness. Special care must be used when handling the chemicals, since they can be harmful to the skin, eyes, and respiratory system. Read and follow the manufacturer's instructions for handling. The chemicals can be brought up to processing temperature by placing the bottles in a tray of very hot water (if you are using Ilford concentrates, heat them up *before* mixing the developer and bleach-fix parts into the stock solutions).

Chromogenic films allow you to change the exposure rating of the film in mid-roll without the need for a change in the developing time. Thus, on the same roll of film, you can produce good negatives of scenes with widely different contrast ranges—something that is all but impossible with conventional black and white films. Photo: K. Tweedy-Holmes.

Processing Chromogenic Films

PROCESSING TIMES AND TEMPERATURES FOR CHROMOGENIC FILMS

	Ilford XP1	Agfapan Vario-XL
Developer	5 minutes at 38 C (100 F)*	7½ minutes at 30 C (86 F)**
Bleach-fix	5 minutes at 38 C (100 F)*	11minutes at 29–31 C (84–88 F)**
Running-water wash	3 minutes at 35–40 C (90–104 F)	4 minutes at 25–35 C (77–95 F)
Final bath	none	1 minute at 25–35 C (77–95 F)
Wetting-agent rinse	30 seconds at room temperature	optional

*Agitate 10 seconds (4 inversions) at the beginning; 10 seconds each minute thereafter during development. Agitate vigorously when bleach-fix is poured in, and frequently thereafter.
**Agitate continuously for the first minute; then every 30 seconds (2 inversions each time).
Note: Do not rinse the film between the developing and bleach-fix steps.

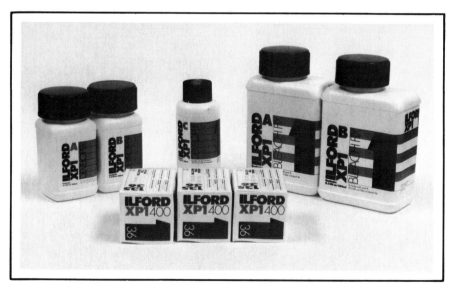

Chromogenic films cannot be processed in conventional, black and white processing solutions. They require their own chemicals, which are the same as those used for color negatives. Shown here is Ilford's processing kit, designed for home processing.

Agfa's chromogenic film is called Vario-XL. It can be processed in Agfa's own color negative chemicals, or in Ilford's solution, shown on the opposite page.

It is possible to develop and bleach-fix with the Ilford kit at lower temperatures with extended times, as follows: 35.5 C (96 F) for 6 minutes; 33.5 C (92 F) for 7 minutes; 31 C (88 F) for 8 minutes; 30 C (86 F) for 9 minutes. It is recommended, however, that development temperatures be kept as close to 38 C (100 F) as possible. If you use plastic tanks, keep the water bath three or four degrees higher than the development temperature.

Push-processing is not recommended, although Ilford says that if its film is shot at ISO/ASA 1600 under very flat lighting conditions, development can be extended to a maximum of 7½ minutes to increase shadow-area contrast. Agfa recommends a routine extension of development time to 8 minutes after two films have been processed in the working solution, and 8 minutes, 45 seconds after 4 films. The working capacity of 500ml of the Agfacolor solutions is six films.

Chemical storage. The shelf life of the Agfacolor Process F chemicals is quite short—in full bottles, six weeks for the developer and eight weeks for the bleach-fix and final bath. The Ilford concentrates will keep for up to one year in full bottles. Ilford stock (mixed) solutions will keep up to three months in full bottles, six to eight weeks in half-full bottles.

Printing. Chromogenic negatives tend to be denser than silver-image negatives, especially if an ISO/ASA rating lower than 400 was used; because of this, longer enlarger exposure times will be required. Apart from this, there is little difference in printing. The negatives can be printed on the same papers with the same chemicals that you use for silver-image negatives.

4

Printing What You Need

Most of the steps in print-making duplicate those you have already learned in film processing. You will again go through the procedures of developing, stopping development, fixing, clearing the fixer, and washing. Time and temperature are again the basis for controlling development, although there is a greater margin of error in printing. You also have one great advantage in print-making that you do not have in film developing. If a print comes out wrong, you can simply discard it and start over; but if a negative is incorrectly processed, there is nothing that you can do except learn from the experience.

Technique Tip: Print-making Accessories

- Enlarger
- Lens
- Printing frame for proof sheets
- Easel
- Filters
- Focusing aid
- Camel-hair brush or canned air
- Timer
- Safelight
- Additional storage containers
- Trays
- Print tongs
- Print washer
- Print dryer, drying frame, or blotter book

This print, with its fully detailed shadow areas and well separated, bright highlights, is a good example of the kind of image quality you can expect if you expose correctly, process the film with care, and print with full attention to the natural qualities of the subject. Photo: K. Tweedy-Holmes.

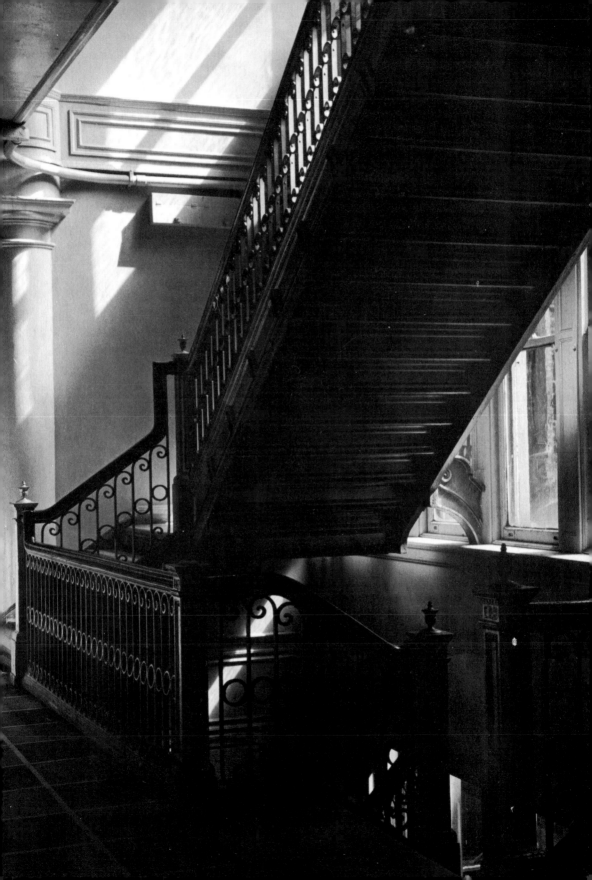

Enlarger

The enlarger is the basic piece of darkroom equipment, and you need a good one to get the best possible prints. It does not have to be the most expensive or most sophisticated, but get the best you can afford. There is little point in having a fine camera if the quality of your pictures is degraded by an unsteady or poorly designed enlarger, or one with an inferior lens.

All enlargers contain certain basic components:

—The enlarger head includes the lamphouse, the negative carrier, and the lens (other features will be discussed below). Focusing is usually done by turning a knob that extends or retracts a bellows between the negative carrier and lens.

—The enlarger head rests on a vertical (either straight or slanted) support column. The size of the enlargement is determined by moving the head up or down the column.

—The support column is attached to a baseboard. The easel containing the printing paper is placed on it when an enlargement is made.

Apart from these elements in common, enlargers can differ in their method of transmitting light through the negative, with a resulting difference in the kind of print that is made.

Condenser enlarger. In this type of enlarger, one or more condenser lenses (which are flat on one side and curved on the other) gather the light from the bulb in the lamphouse and direct it in parallel rays through the negative. In a true condenser enlarger, the light source is a clear bulb, and it is necessary to focus the condenser lenses as well as the enlarging lens. But a frosted opal bulb is usually used, which makes the enlarger a combined condenser/diffusion type to some extent.

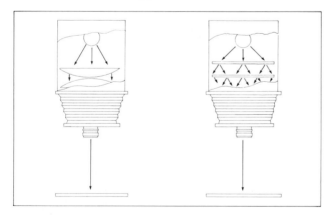

The enlarger at left uses condensers which take scattered light produced by the enlarging lamp and direct it in a concentrated beam through the negative. This produces sharp, "snappy" images, but also makes negative scratches and dust more obvious in the print. A diffusion enlarger (right) has no condensers to direct light to the negative stage. The scattered light of the bulb reflects off the white walls of the lamphouse, giving the negative soft, even illumination. This enlarger type produces slightly less visual sharpness but gives more subtle separation of tones and less obvious rendition of scratches and dust.

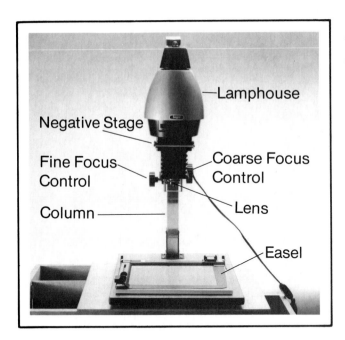

Diffusion enlarger. With this kind of enlarger, the light passes through frosted glass or a diffusing screen before it reaches the negative. A frosted bulb is used, and the lamphouse is round and highly reflective to insure the evenness of the light. A variation of this is found in the *cold-light enlarger,* which uses a grid framework of one or more gas-filled tubes as a light source. This makes an even distribution of light easier to achieve, and the light reaches the negative with very little heat.

Which is best? Because the light in a condenser enlarger is more concentrated as it passes through the negative, it gives more contrast and apparent sharpness to a print than the diffusion type. And you are more likely to be able to print within the normal contrast range of printing papers and filters when using a condenser enlarger. In addition, exposure times are shorter—a definite advantage when working with small negatives.

On the other hand, the light concentration which gives the condenser enlarger its advantages also causes its drawbacks. Every speck of dust or scratch on the negative shows up sharply, and grain is more evident. These problems are minimized with a diffusion enlarger. It spreads out the light and softens the image, making defects in the negative less noticeable. For this reason, it is a popular choice for portrait work. But it lowers contrast, and a print made on No. 2 paper, or with the equivalent filter, would look flatter in its tonal range than one enlarged with a condenser head.

With some condenser enlargers, it is possible to place diffusing glass in the lamphouse to achieve many of the effects of a diffusion enlarger.

Negative carriers are available in "glass" or "glassless" varieties. The glassless types (left) are faster in use, and will not trap dust particles on the surface of the negative. However, they do not ensure the same degree of negative flatness that glass carriers provide.

What to Look for in an Enlarger

Versatility. As your darkroom skills develop, you may want to try out new possibilities, for example, to use larger negatives to get finer grain and a more subtle tonality in your pictures, or to take on the challenge of color printing. Many reasonably priced enlargers will accommodate not only 35mm and smaller formats, but also the 6 × 6cm (2¼″ × 2¼″) or 6 × 7cm (2¼″ × 2¾″) negatives made from 120 roll film.

Many standard enlargers are easily adapted for basic color printing, especially if the filter drawer is in the lamphouse and if a diffusing screen can be placed in the lamphouse. Some enlargers have a modular design. With these, you can buy the enlarger with a condenser lamphouse for black-and-white printing, then later buy an interchangeable color head (which has a built-in filtration system and usually has diffused illumination). Still others have dual condenser and diffusion systems.

Sturdiness. You can often tell by looking whether an enlarger's construction is solid, but if in doubt, test it for steadiness by raising the head to its highest point and rapping the head, support column, and baseboard. Any vibration of the head should die out quickly. Also, the elevating mechanism should be smooth and should hold the head securely in place on the column. Unsteadiness will be a problem with the thin, tubular columns of the cheaper enlargers, and clamp like locks for heads are more likely to cause trouble than the counterbalancing and friction types.

Alignment. For maximum print sharpness, there must be parallel alignment of the negative carrier, lens, and baseboard. Again, you may have difficulties with the tubular columns. Unless these are quite rigid, the enlarger head can pull forward enough to put the negative and lens out of line with the baseboard.

Evenness of illumination. Light must be directed evenly over the entire negative area. When using both 2¼″ and smaller negatives, it is an advantage to have either interchangeable condensers for the different formats, or an additional condenser that you place in the lamphouse for 35mm and smaller formats.

Negative carrier. Glassless carriers, which consist of two metal frames between which the negative is inserted, are easy to use, and it is also easier to clean dirt off the negative. However, they do not keep the negative as completely flat as glass carriers, and the negative may bulge out if it gets too warm. Glass carriers sandwich the negative between two pieces of glass. Flatness is thus guaranteed, but it is harder to get dust off the negative, and dust on the top or bottom glass will show up on the print.

In practice, glassless carriers usually work fine for 35mm and smaller formats. Also available are combination carriers, which have a glass top and metal-frame bottom.

Filter drawer. Most enlargers have a filter drawer in the lamphouse. The location is important; because if the filter provision is below the lens, print quality will be degraded. In black-and-white printing, the filter drawer holds the contrast-changing filters for variable-contrast papers.

The filter drawer in your enlarger lets you place variable contrast filters above the lens stage. With this method, there is no risk of degrading the image; placing filters in a holder under the lens might cause you to lose a certain amount of sharpness, especially if the filters you use are not absolutely clean.

Enlarging Lens

Enlarging lenses are designed optically especially for their close distance to their subject (the negative) and for the negative's flat field. They differ widely in quality and price, and although some "bargain" lenses perform adequately when stopped down (used at less than their widest openings), usually with an enlarging lens you get what you pay for. An inferior lens will be a severe obstacle to getting good prints, so get the best you can afford. Fortunately, a good enlarging lens is much less expensive than a camera lens of comparable quality. Take the following factors into account before making your purchase:

—Sometimes a lens is supplied with the enlarger. This often happens with the cheaper enlargers, and the lenses are less than top quality. It is better to buy the enlarger without a lens, then select a lens on its own merits.

—Even with highly rated lenses, quality can vary quite a bit from lens to lens. If possible, get a guarantee that the lens can be returned to the store if it is not satisfactory. Then, at home, perform the tests described in the lens testing section below.

—For each negative size, there is a corresponding "normal" enlarging lens in terms of focal length. Most commonly, this means a 50mm lens for 125 and 35mm negatives, a 75mm lens for 6 × 6cm (2¼" × 2¼") negatives, and a 90mm lens for 6 × 7cm (2¼" × 2¾") negatives.

—Generally, the widest aperture necessary in an enlarging lens is *f*/3.5 or *f*/4. This provides adequate illumination for focusing in almost all cases, and lenses that open up to *f*/2.8 are considerably more expensive.

Your enlarging lens is at least as important as the lens you use on your camera. Your prints can only be as good as the enlarging lens you use to make them, so buy the highest quality enlarging lens you can afford.

Make your own enlarging lens test negative by taking an exposed, processed piece of film and carefully etching crosses at its center and in each corner. Use the test negative as described in the text; it will show you whether or not your lens gives sharp results across the entire image field.

Lens testing. There are two tests that even a beginning darkroom worker can perform to determine the quality of a particular lens:

Sharpness. Purchase a Kodak test negative, or make one yourself by taking a processed, blank negative and scratching parallel lines or an X into the center and into each corner. Position the negative in the negative carrier and raise the enlarger to its highest position. With the lens at its widest aperture, project the negative onto a flat, white surface (this can be paper, cardboard, or the baseboard itself if it is white enough). Using a focusing aid, if you have one, focus the center marking, then check the corner markings. If the corner lines look as sharp as the center pattern, the lens passes the test.

Often the lens will have to be stopped down to get maximum corner sharpness. If only one stop or two is required, the lens will be adequate for most enlarging purposes, although there will be times when you will need a wide opening for very dense negatives.

Evenness of illumination. Raise the enlarger to the proper position for at least an 8″ × 10″ print. Position the easel and focus a negative, then remove the negative and with room light off and safelight on, put a piece of enlarging paper into the easel. With the lens at its widest opening, turn on the enlarger for a few seconds. Develop and fix the paper as described in Chapter 5. The result should be an even gray tonality over the entire print area (if the print is too dark or too light, expose another piece of paper with either half or twice the amount of exposure as before). If there is a falling off of tonality at the corners, the illumination is not even. This can be corrected during actual enlarging, but it is better not to have to do so. Again, the results may improve when the lens is stopped down, and this will give you another standard for the optimum aperture of your lens.

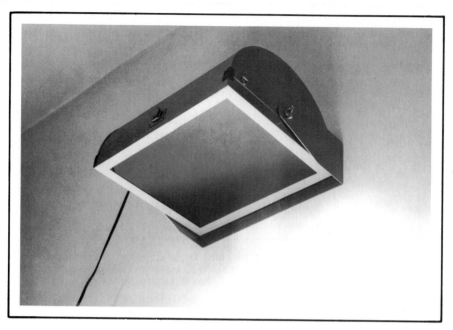

Safelights will not fog printing paper, as long as they are fitted with the appropriate filter, and are kept at the distance recommended by the paper manufacturer.

Basic Equipment

Safelight. Your darkroom must have one or more safelights to enable you to see what you are doing without fogging the printing paper. (See Chapter 1 for a general discussion of safelight requirements and testing.) Again, numerous models are available commercially. For black-and-white enlarging papers, the safelight you buy should be equipped with an OC (amber) filter, and for home darkroom use it should have no more than a 15-watt bulb. Besides these, there are no special requirements other than what is convenient for your own setup.

Timer. A good timer makes your printing much easier and more precise. A simple spring-wound type is adequate if economy is important, but such timers must be reset after each exposure. This is a time-consuming annoyance, which can also lead to unwanted timing variations from one exposure to the next. Timers with full electronic operation are preferable, and some of them cost only a fraction more than some of the spring-wound models.

With an electric timer, the enlarger is plugged into the timer, which then controls the switching. The timer turns the enlarger light on for the exposure period and off when it ends. The timing needle automatically returns to its preset position, usually on a luminous dial. The timer also has a switch for turning the enlarger lamp on for focusing without activating the timing needle. Some timers can be set for extended time periods, which is handy if you want to use a timer for film developing; but for printing, a 1- to 60-second range is quite sufficient.

Proof-sheet Printing Frame. This frame enables you to use your enlarger to make a contact print of the negatives and get your first real look at your pictures. Several variaties are available commercially. They consist of a flat base to hold the printing paper in place, and a hinged glass or plastic cover that is grooved to hold the negative strips. These frames are handy and relatively inexpensive, but plastic covers are easily scratched. This does not harm your negatives, but ultimately it will result in a network of white lines on the surface of your proof sheets.

You can make a proofing frame yourself. Use a sturdy piece of composition board or a hard sheet of plastic for the base. Use plate glass, a little larger than 8″ × 10″, for the cover. Heavy duct or gaffer's tape will serve as a hinge. Make sure the edges and corners are taped carefully to avoid cuts.

Easel. The easel holds the paper flat and in position when the exposure is made for an enlargement. The kind most commonly used has a metal base and two adjustable blades for setting the size of the enlargement. There are also easels with fixed sizes, but those with adjustable blades are much more flexible, since they allow you to make enlargements of any size up to the maximum provided for by the particular easel. However, if you want to make prints that are not the size of standard printing papers, you will not get even borders with two-bladed easels unless you trim the paper. The solution to this is an easel with four adjustable blades. This enables you to set the borders any way you like, but a four-bladed easel, although very convenient is expensive.

Many photographers prefer borderless easels, which allow them to use the entire surface area of the paper for the print. With these easels, the paper is held in position by retaining bars or corners, which are magnetized or locked into place.

Photographic easels are used to keep the paper flat during exposure. The adjustable blades of the easel shown allow quick and convenient cropping of the projected image.

Other Necessities

Trays. You will need a minimum of three trays, one each for the developer, stop bath, and fixer. Another will be required if you use a tray and siphon method of print washing (see below). If you print on fiber-base paper, you will need another tray for the washing aid. For maximum permanence of fiber-base papers, many photographers use two fixing baths and also tone their prints with a highly dilute selenium solution. If you decide to follow these procedures, you will need extra trays for the chemicals. You may also need a tray filled with water for holding prints before taking them to the wash area.

It is an advantage, although not essential, to use trays that are a size larger than the paper to be processed in them, for example, using an 11″ × 14″ tray for 8″ × 10″ prints. This allows easier print handling and agitation. Trays that are ridged on the bottom are preferred. They help insure that the chemicals reach all areas of the emulsion even when the print is face down, and also make it easier to get print tongs under the print to get it out of the tray.

Print Tongs. The most common types are plastic or wooden with rubber tips, and their use is definitely recommended. Using your fingers to pull prints out of processing solutions necessitates repeated handwashing to make sure the chemicals and the negatives are not contaminated.

Get a different pair of tongs for each chemical; they are not expensive. It is especially important that tongs used with other chemicals not be put into the developer.

Use a separate tray for each of your processing chemicals, and a separate pair of tongs for each. Label the trays and the tongs to avoid the risk of contaminating your solutions.

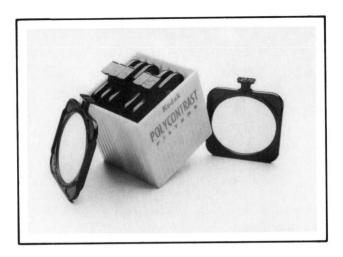

Variable contrast filters, used with the appropriate paper type, will let you produce different grades of contrast without having to buy a series of different paper grades.

Storage Containers. You will need additional containers for each chemical used for printing, since chemicals should not be used interchangeably for film and print processing. The characteristics and advantages of different types of storage containers are described in Chapter 2.

Variable-contrast Filters. Use in conjuction with variable-contrast papers (discussed later in this chapter), these enable you to change print contrast without having to use different grades of printing papers. This is both time-saving and economical, since only one box of printing paper serves almost all your enlarging needs. Many manufacturers of printing paper and enlargers provide filters especially designed for (but not restricted to) use with their own products. As with paper contrast grades, the lower the filter number, the softer the contrast. Some filters come in half-grade increments, which add to their usefulness. Make sure the filters you buy fit your enlarger's filter drawer.

Camel-hair Brush or Canned Air. The importance of having the negative as dust-free as possible when it is in the enlarger has been stressed frequently. One way to get rid of dust specks is by brushing the negative surface gently with a soft camel-hair brush. Do not use a brush with stiffer bristles, as the negative might get scratched. An alternative method, often easier and more effective, is to blow off the dust with a blast from a can of compressed air, such as Dust-Off.

Focusing Aid. This device magnifies a portion of the image projected by the enlarger and makes focusing more precise. A focusing aid is especially helpful when making large enlargements, printing very dense negatives, or when there is no sharply defined detail in the image. Many photographers use one for every enlargement to help guarantee maximum sharpness.

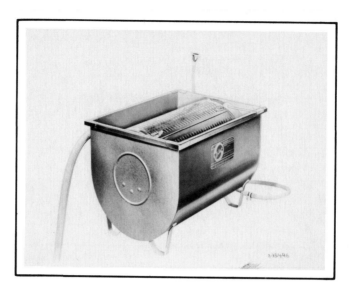

Drum washers, such as the one shown, are extremely effective since they keep the prints in constant movement. In this model, water pressure provides the power.

Print Washer

Resin-coated enlarging papers do not require much washing to rid them of fixer, but fiber-base papers are another matter. They require a considerably longer wash period, for maximum permanence even with a washing aid. Insufficient washing will result in stains or fading, so an effective washing method is imperative. As with film washing, effective print washing requires the elimination of the hypo that tends to settle at the bottom of the washing tray or tank; Simply allowing water to splash down into a tray will not suffice. For resin-coated papers, a simple tray wash method is adequate if the water is changed several times and if the print is agitated each time the tray is filled. This method works for fiber-base papers also, but the extended washing time required makes it a tedious procedure.

Tray and siphon. The process of washing in a tray is much easier if you use a siphon, such as the Kodak Automatic Tray Siphon. This unit, which consists of a siphon and a faucet connector with rubber tubing, can be connected to any standard processing tray. It keeps the water in the tray continuously circulated and drained to facilitate washing. This is an excellent method for resin-coated papers, since they are generally washed one at a time. It is less advantageous for fiber-base papers, which are seldom washed one by one because of the longer wash time required. When several prints are loaded into a tray-and-siphon setup, they must frequently be separated by hand. If print surfaces are left touching each other, portions of the prints will not be adequately washed.

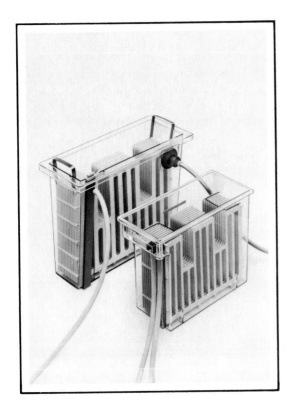

Vertical washers use racks to keep prints from touching one another as they wash. These washers are generally available in two sizes: one for 8" × 10" prints, the other for the larger, 11" × 14" size.

Water turbulator. The Ganz De Hypo Print Washer is a very inexpensive washing device, designed to convert a sink into a print washer. It consists of a rubber drainage unit that covers the sink drain and a rubber hose that attaches to the faucet. The hose forces water into the bottom of the sink and around the sides so that maximum water circulation is achieved. But with this unit as well, prints will have to be separated frequently to insure adequate washing.

Rotary washers. These are round, plastic tanks that are also connected to a faucet with a rubber or plastic hose. With the units made by Richards, three jets of water shoot into the tank, and the water which partially fills the tank is forced into a circular pattern around the sides. The drainage is at the bottom, in the center of the tank, and this efficiently eliminates the residual hypo. Rotary washers do a fair job of keeping prints separated if only a small number are washed at a time. However, if these tanks are filled with the number of prints proclaimed by the manufacturers, a lot of manual separation will be required.

Vertical washers. These are definitely the most effective washers for getting chemicals out of fiber-base papers, and they are generally the choice of photographers who are concerned about "archival" permanence for their prints. In these washers, prints are held in compartments or racks that keep them separated.

Print Dryer

Resin-coated papers present no drying difficulties. Just place the wet prints on a clean, flat surface, such as a sheet of hard plastic or a formica countertop, and they will be air-dried in about an hour. Drying will take only one-third to one-half that time if excess water is wiped off first.

Drying screens. Air-drying fiber-base papers is accomplished most effectively with fiberglass or plastic screens attached to wooden or aluminum frames. A commercial version of this is available, the Archival "Open Air" Dryer, but it is simple to make one yourself. The screening material you will need is the sort designed as a substitute for wire window screens, and is obtainable from hardware and lumber stores. Sometimes you can purchase it already attached to aluminum frames. If not, you can easily attach the screens to wood strips fastened together to make a wooden frame. If the wood strips are about two inches deep, the frames will be stackable. Be sure to use only plastic or fiberglass screens; wire screens will rust and stain your prints. Clean the racks frequently to make sure they are free from chemical contamination. Place fiber-base papers face down on the screens to minimize curling.

Electric heat dryers like this one use a heated drum to dry the print. Prints are placed on a cloth apron and brought into contact with the drum. The highly polished, metallic drum surface will give an extremely glossy surface to your prints if you place them in the dryer face up. If you are after a less "slick" finish, place your prints in the dryer with their emulsion side on the curtain. This kind of dryer should not be used with resin coated papers.

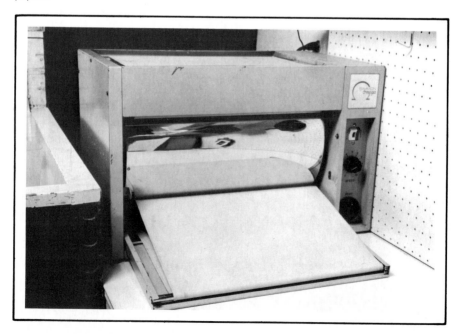

Drying screens are the preferred drying method of most photographers who are concerned about maximum print permanence, since there is very little danger of chemical contamination if the screens are kept clean. Fiber-base papers require two to five hours or longer to dry, depending on humidity and air circulation. As noted, a flat surface is really all that is needed for drying resin-coated papers, but if you are processing large numbers of prints, the screens can be very helpful. An alternative unit is made by Paterson. It is a drying rack, recommended by the manufacturer especially for resin-coated paper, that holds the prints vertically while they are air-dried. A unit by Falcon consists of a vinyl-covered wire rack, but it also has rollers to squeeze off excess water.

Blotting paper. Blotting material comes in books or rolls and is a very inexpensive drying method—the first time through, at least. Since you will use up numerous books or rolls over a period of time, the expense will increase considerably in the long run. Blotting paper is convenient and takes up very little space, but it is also the slowest means for drying prints. It will take a day or two—longer in very humid areas—for a fiber-base paper to dry in a blotter book. Also, unless fiber-base prints are thoroughly washed, there is a real danger of chemical buildup in the blotting material, which will contaminate the prints as they dry. In addition, some cheap blotting paper, as well as blotting material not specifically designed for photographic use, is chemically impure and can contaminate the prints. If you use blotter books or rolls, make sure they are good-quality photographic blotters and wash your prints well.

Electric dryers. Those designed for home use usually come with ferrotype plates (chrome-plated metal sheets) and a canvas cover, or "apron," to hold the prints down. These units dry the prints with heat. Most of them have thermostats to control the amount of heat, and many can be flipped over to allow simultaneous use on the top and bottom. They greatly speed up the drying process—fiber-base papers can be dried in 15 minutes or less. They can be used for drying resin-coated papers only if the heat is kept at a minimum (no more than 32 C (90 F)), and even then their use is neither recommended nor necessary.

Glossy-surface fiber-base prints can be dried emulsion side down on the chrome sheets to get a glazed, high-gloss finish. This process is called ferrotyping, and since it does not require heat, it can be accomplished without the unit being turned on.

The biggest disadvantage of the electric dryers is the chemical contamination that will build up in the canvas apron if each print dried is not completely washed. This contamination will then be passed on to other prints dried on the machine. Electric dryers are effective and quick, however, and can be useful if processing must be done as quickly as possible, and if prints are adequately washed and the aprons kept clean. These dryers will also slightly darken the tonality and intensify the contrast of a print, a factor to be taken into account during the printing process.

Printing Papers

There are many kinds of printing papers you can use for black-and-white enlarging, and they come in a variety of image tones, textures, and contrasts. Your first choice, however, will be whether to use the traditional fiber-base papers or the newer resin-coated (RC) papers. The choice is a fundamental one, since the processing procedures and, to some extent, the equipment and chemicals used will be different for each type.

Fiber-base papers. With this type, the light-sensitive emulsion (as with film, composed of a crystallized silver compound suspended in gelatin) is coated onto paper stock. Fiber-base papers are currently available in a wider variety of surface textures and image tones than are available in RC papers.

The primary disadvantage of fiber-base papers is the lengthy processing they require. The paper base absorbs chemicals readily, and thus it is difficult to wash it completey free of fixer. Even after you use a washing aid, 30 minutes to an hour of washing may be necessary for real print permanence, and in archival processing (designed to enable prints to last for hundreds of years), even more washing time is recommended.

Resin-coated papers. RC papers ae unquestionably easier to use. With them, the emulsion is coated onto paper that is covered on both sides with polyethylene. The paper base is thus waterproofed and will not absorb chemical solutions. It is not difficult to get the residual fixer out of the emulsion, so washing time is reduced to four or five minutes or less, with no washing aid required. Other processing steps are shorter as well; in fact, one company asserts that by using its products you can reduce total processing time, from developing through washing, to just four minutes. RC papers also dry much faster than fiber-base papers.

This ease of processing makes RC papers very advantageous for the beginning darkroom worker, or for one whose space and facilities are limited. No special print washer or dryer is needed, for example. Another advantage is that RC papers stay flat—on the easel and after drying. Fiber-base papers, on the other hand, are sometimes prone to curling if air-dried, or ruffling at the edges if heat-dried.

With all these advantages, why is RC paper not universally used? The reason lies with the surface characeristics and tonal reproduction of fiber-base papers, as discussed below.

Surface. *Glossy* papers, both fiber-base and resin-coated, give the most extended tonal range and reproduce the most detail. Glossy RC papers dry naturally to a highly polished finish, but glossy fiber-base papers must be ferrotyped (dried while pressed against a chrome-plated metal sheet) to get this high-gloss look. If dried without ferrotyping, fiber-base papers, will retain their tonal qualities but will have a smooth, unglazed surface. Many photographers prefer this look for their exhibition work.

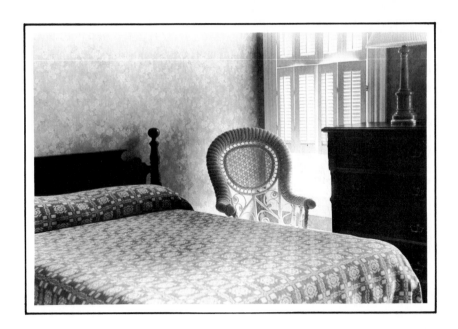

Glossy surfaced printing papers are the best choice for most general printing. If you dry them without ferrotyping, the surface will have a high sheen, allowing the full tonal range of the image to come through. Photo: K. Tweedy-Holmes.

For a long time, it was considered almost axiomatic that the best glossy fiber-base papers provided a better tonal rendition, and thus a better-looking print, than RC papers. However, higher silver prices have caused manufacturers to make some compromises, and the quality of fiber-base papers is more varied than it once was. In addition, some paper types or certain contrast grades or weights (thickness) have been discon tinued altogether. To compensate, some manufacturers have introduced special papers with higher quality—and a higher price—than standard papers. At the same time, as RC papers have increased in popularity, im provements have been made, and more surface types have become available.

Some paper surfaces are described as *matte*. These give prints a much-reduced surface brilliance and a reduced tonal range. They also minimize grain, dust spots, and negative defects. They can be useful in portraiture or in lending a subdued "mood" to a picture. Surfaces that fall between glossy or matte are called, depending on the manufacturer, high lustre or pearl, lustre, semi-matte, velvet matte, and so forth. None of these sur faces are designed for ferrotyping, and they are available in one brand or another in both fiber-base and RC papers.

Various surface textures are also available, and for the most part their names are self-explanatory: smooth, fine-grained (slightly pebbled), velvet stippled, silk, tweed, rayon, linen, burlap, and so on. The papers you will undoubtedly be using in the beginning will be smooth; the other tex tures are designed mostly for special effects.

More About Papers

Image tone. A printing paper is called *warm* when it gives a brownish tone to the image. Prints made on *neutral* paper have a gray-black or slightly olive tonality. If the image tone tends toward blue, the paper is said to be *cold*. There are in-between designations as well, such as warm-black, brown-black, or blue-black. The most commonly used papers are either warm-black or neutral (tending sometimes toward cold) in their tonality.

Contrast. Many papers are available in different contrast grades. These grades are usually given a numerical value—the higher the number, the higher the contrast of a print made on that paper. Depending on the paper, No. 2 or No. 3 grades are considered "normal." That means that correctly exposed and developed negatives will print best on them. If the negative has either a higher or lower than normal contrast, a different grade of paper can be used to compensate.

Obviously, it is expensive to have three or four boxes of printing papers on hand to provide for contrast compensation. The alternative is variable-contrast paper. With this type of paper, contrast is controlled by filters, which are generally placed in a filter drawer in the enlarger lamp-house. The numbers given to the filters are equivalent to those for paper grades, and usually a variable-contrast paper used without a filter is equivalent to a No. 2 graded paper. Variable-contrast papers are a great advantage when money and space—or just easy handling—are considerations.

It is sometimes claimed that prints made on graded paper have a richer tonality than those made on variable-contrast paper, yet most people would have a hard time in detecting much practical difference in quality. In fact, many exhibition prints are made on variable-contrast paper. Both fiber-base and RC papers are available as either graded or variable-contrast papers.

Weight. Fiber-base papers generally come in two thicknesses: double-weight and single-weight. Double-weight is essentially twice the thickness of single-weight and is more expensive. It also takes longer to wash. Double-weight papers are much sturdier, however. Single-weight papers require more careful handling during processing, and in some types of washers they can get battered to the degree that wrinkles are apparent in the print after drying. They are handy for making proof sheets, and they can be used without too much difficulty for prints up to 8" × 10". For larger prints, double-weight paper is easier to handle.

Resin-coated papers are available only in an in-between thickness, medium-weight.

Paper tint. Most printing papers have white paper stock, which is preferable for most enlarging purposes. With a few papers, the stock is

"warm white" or "cream white." These can be used to give a warmer quality to the print tonality.

Speed. Paper emulsions have different degrees of sensitivity to light; the greater the sensitivity, the greater the speed and the shorter the exposure time that is required to make a print. This is not a factor to be considered in choosing an enlarging paper, since any of the papers you are likely to use are medium to fast and will not require unduly long exposures.

Special-purpose papers. Contact-printing paper is designed for use in making contact prints of large-size negatives. These papers require a special contact printer since they are too slow for use with an enlarger. You will have no reason to consider them for any of your enlarging requirements. Kodak Panalure Papers are designed for making black-and-white prints from color negatives. If you should have occasion to use them, note that they require a different safelight filter—a No. 10 or No. 13 dark amber filter.

Which paper to choose. It is really not difficult to sort through the different possibilities when deciding which enlarging paper to use in the beginning. A good first choice would be a glossy-surface, neutral or warm-black paper. An RC paper is recommended for its ease of processing, and a variable-contrast paper will make your work even easier. With these factors as a basis for selecting, your choices are narrowed considerably inasmuch as only two printing papers meet these requirements: Ilford Ilfospeed Multigrade and Kodak Polycontrast Rapid II. If you appreciate the convenience of these papers, but do not like the high-gloss finish, try the pearl surface of the Multigrade or the high-lustre version of the Polycontrast.

If you want to use graded RC papers or either variable-contrast or graded fiber-base papers, you have a great many possibilities. Agfa-Gevaert, Ilford, and Kodak make some excellent papers (Agfa, however, does not manufacture a variable-contrast paper). High-quality "special" papers include Ilford Galerie, Unicolor Exhibition, and Oriental Seagull. These are available only as graded fiber-base papers.

Paper storage. Keep printing papers in a place that is dark, dry, and cool. You can store a package of paper that is being used in a drawer or closet. However, if you buy paper in large quantities, to use over long periods, it is a good idea to refrigerate them. They can even be frozen for long periods. A paper that was stored in the freezer can be used beyond the paper's expiration date. Otherwise, avoid outdated paper, as it can produce fogged prints.

Printing paper must be stored in darkness. Once it has been opened, even the box in which the paper is packaged may not be safe if it sits too long in a brightly lighted room. For this reason, you may want to get a paper safe—a lighttight box or small cabinet designed especially for printing paper.

Chemicals

Developer. The basic consideration in choosing a paper developer is its compatibility with the image tone of the printing paper you intend to use. If, as recommended, you are using a paper that falls within the warm-black to cold range, you will need a neutral or cold-tone developer. Many of these can be considered general-purpose developers, because they work well for many commonly used papers. Some of the good ones are Kodak Dektol, Ilford Ilfobrom, Unicolor B&W Paper Developer, and Edwal Platinum and Super III.

Other considerations:

—In choosing a developer it is a good idea to use the one recommended by the paper manufacturer. If in doubt, try Dektol. It gives very good results with a variety of papers.

—In some cases, a developer is designed for a particular paper. Ilford, for example, makes developers that allow quick development of their variable-contrast papers.

—Some developers will alter, usually only slightly, the normal tonality of a paper. For example, Kodak Selectol will give a neutral paper a warmer tone, and a colder tone can be obtained from Unicolor Cold Tone Developer. The paper used is the basic determinant of image tone, however, and for a truly warm or cold print quality, use a warm paper/warm developer or cold paper/cold developer combination.

—Some developers can be used with warm, neutral, or cold-tone papers by changing the degree of dilution of the working solution. Ethol LPD and Edwal TST are examples.

—Generally speaking, the so-called "universal" developers designed for both film and paper should be avoided. Use a developer designed specifically for printing papers.

—The graininess of an image will not be affected by the paper developer that is used. Graininess is a characteristic of the negative, although it can be masked somewhat with a textured printing paper.

Stop bath. Always apply a stop bath after removing a print from the developer. This is done not to control development, but to extend the life of the fixer. A slightly extended development time makes no discernible difference in the appearance of a print. However, several different negatives may be enlarged during a printing session, and if as much developer as possible is not removed from these prints, the fixing bath will become exhausted more quickly. The stop bath also reduces emulsion swelling and reduces the possibility of certain kinds of stains.

The same acetic acid stop bath used for films is used for prints. Handle it carefully to prevent burns (see Chapter 2). Follow the manufacturer's dilution instructions, since too strong a solution can stain prints or damage their emulsion, and too weak a solution will not work effectively.

If you use an indicator stop bath, don't wait until it turns purple to discard it. As soon as you notice a slight color change, get rid of the work-

ing solution. It is best to use the 28 percent acetic acid solution diluted to the proper degree. The solution will be colorless, so you must keep count of the number of prints that go through it. Discard the solution *before* the recommended maximum is reached.

Fixer. A fixer with a "hardening agent" was recommended for film processing, but this hardener is not really needed for prints. In fact, the use of a hardening fixer inceases wash time for fiber-base papers (and for RC papers as well, although this still means a maximum of about five minutes). You can avoid the hardening agent by selecting a two-solution fixer such as Kodak Rapid Fixer or Edwal Quick-Fix. These consist of a liquid concentrate basic fixer and a separate hardening solution. Thus, you can use the two solutions together for films and use only the basic fixer for prints. If your prints are scratching easily, use a medicine dropper to squeeze a few drops of the hardener into the fixer working solution. Of course, you can use the standard "general-purpose" fixers for your prints if you take into account the extra wash time (not much of a factor for RC paper). The general-purpose fixers are usually sold in powder form and are therefore cheaper.

Washing aid. This is required only for fiber-base papers, and you use the same kind for films and for prints.

Storage. Photographic chemicals have a limited shelf life, so do not prepare solutions in larger quantities than can be used up in a reasonable length of time. See Chapter 2 for a discussion of storage requirements.

Technique Tip: Chemical Storage

To insure having chemicals that are fresh and ready to use, it is important to store them properly. Air, temprerature, and light all affect the shelf life of photo chemicals. Ideally you should:

- Always store chemicals in dark or opaque containers with tight sealing lids.
- Store the chemicals in a dark place where the temperature does not fluctuate more than a few degrees from 68 F.
- Never store developer in a container that has been used for any other chemicals.
- Minimize the amount of air in your storage bottles; collapsible bottles are best.
- Always store photo chemicals away from small children.

5

Making a Proof Sheet

After processing your film, the next step is to contact-print the negative strips onto a piece of 8" × 10" enlarging paper to make a proof sheet. A proof sheet is important for several reasons. First, it gives you your first look at your pictures as positive, rather then negative, images. These images will be quite small, of course, but they will give you a good idea of which pictures you want to enlarge. In addition, since an entire roll of film is contact-printed onto one sheet of paer, the proof sheets serve as a valuable record of your photographs and a handy reference for locating negatives.

A proof sheet also gives you a preliminary indication of which contrast grade of paper or filter is required. And if some of the images are darker or lighter than others, you will know that longer or shorter exposure times will be required. You will learn, however, that a process of visual translation is necessary, since an image that looks well balanced in its tonality on the proof sheet may turn out to have more or less contrast than you thought when you try to enlarge it. With experience, you will also be able to determine if cropping would strengthen the picture.

A proof sheet is processed in the same manner as an enlargement, using basically the same equipment. The one additional item needed for proof sheets is a printing frame, either purchased or homemade, or a piece of plate glass (well taped around the edges) to hold the negatives against the printing paper.

Some photographers keep an inexpensive brand of printing paper on hand just for making proof sheets, and this is a good idea if you shoot a lot of film. Single-weight, fiber-base papers are the cheapest to buy, but here again you may well find that the convenience of RC papers offsets their extra cost.

Make your proof sheets on No. 2 paper or with a No. 2 filter. This will help you judge if your negative contrast is normal.

A properly made proof sheet will not only give you a positive rendition of your negatives; it will also help you decide on which grade of paper your enlargement should be made. Note the photographer's markings, indicating picture selection and cropping.

Preparation

Refer to Chapter 3 for the procedures to follow, and the precautions to take, when mixing chemicals. The temperature of the working solutions should be as close to 20 C (68 F) for the developer, although for the other chemicals it can be 18 to 24 C (65–75 F). If your darkroom temperature is close to 20 C, no special temperature control measures are necessary. If it is too high, you can cool the solutions by periodically dipping a plastic bag filled with ice cubes into them. If the darkroom temperature is too low, you can dip a film developing tank containing hot water into the trays. When working for extended periods, you can control temperatures by placing the processing trays into larger trays containing water which is kept at the desired temperature.

When you begin the printing session, plug the enlarger into the timer (if it is an electric one) and make sure the safelights are plugged in and in the proper position (at least four feet from wherever the printing paper will be exposed). Make sure the glass or plastic cover of the printing frame is clean, if you are using one, and insert the negatives into the grooves emulsion (dull) side down.

Prepare the wet area by first setting out the trays for each chemical. Remember that they should be set out so that you are working away from the enlarger and toward the wash area or water tray. If you will be using a print washer and/or dryer, have them ready.

Measure out the chemicals, with dilutions as required, and pour them into the trays. If you plan to make several proof sheets and prints during the session, put 1 liter (32 oz) of working solution into an 8″ × 10″ tray. If you use Dektol, a 1:2 dilution will be required, and 8 ounces of developer and 16 ounces of water will be a sufficient amount. You can use lesser amounts of solutions if only a few prints will be processed, but the trays must be full enough for the paper to be completely submerged.

Technique Tip: Storing the Proof Sheet

Some photographers punch holes in the proof sheets and file them in ring binders beside the corresponding plastic negative holder. This is a convenient and efficient way of locating a particular negative. However, if you file your proof sheets and negatives separately, a cross-reference system may be helpful. You can do this by numbering both the proof sheet and the negative file. It is also a good idea to date the proof sheets and to write on the back any technical information you may want to remember.

Proof prints make it easier to choose one negative from a series shot of the same subject.
Shown below is a proof sheet; above, the print chosen from it by the photographer. Examine
the proof sheet to see whether or not you agree with the choice made.

Making the Proof Sheet, Step by Step

Step 1: Getting Ready.

1. Turn on the safelight and turn off the room light.
2. If you are using a printing frame, place it (without paper) on the baseboard of the enlarger. If you are only using plate glass, use an 8″ × 10″ piece of cardboard for this step.
3. Turn on the enlarger light and raise the head until the light covers an area a little larger than the printing frame or the cardboard. Position the frame or cardboard until they fit within the area covered by the light.
4. Turn off the enlarger light or swing the red filter into place. Put the enlarging paper, emulsion (shiny) side up, into the frame and fasten the cover down. Or place the paper where the cardboard was positioned, put the negative strips (emulsion down) on the paper, and put the plate glass on top. A piece of foam rubber under the paper will help insure that the negatives are pressed evenly against the glass.

Step 2: The Test Sheet. If you make a test sheet, it will be your guide to subsequent proof-sheet exposure times. Here's how:

1. With the printing paper and negatives in place, cover approximately one-sixth of the paper area with a thick 8″ × 10″ piece of cardboard.
2. Expose the paper with the enlarger light for two seconds.
3. Repeat this exposure five more times, each time uncovering another one-sixth of the paper area (for the last exposure, the paper will be completely uncovered). This procedure will give you exposures of 2, 4, 6, 8, 10, and 12 seconds.

Step 3: The Developer.

1. With the enlarger light off, put the printing paper into the developer. It doesn't really matter whether the paper goes in face up or face down as long as your safelight is truly safe, but if it is face down, make sure the paper is not flat against the bottom of the tray.
2. Agitate gently by raising a corner or end of the tray up and down. Develop fiber-base papers for 2 minutes, RC papers for 1 to 1½ minutes.
3. Lift the print out of the developer (use print tongs) and let it drain for a few seconds.

Step 4: The Stop Bath.

1. Slip the print into the stop bath. (Do not let the print tongs get into the stop bath solution, or they will subsequently contaminate the developer.)
2. Leave RC papers in the stop bath (with agitation) for 5 seconds, fiber-base papers for at least 15 seconds.
3. Remove the print and allow to drain.

Step 5: The Fixer.

1. Put the print into the fixer.
2. Agitate gently. RC papers require from 30 seconds to 2 minutes in the fixing bath, depending on the products being used, so be sure to follow manufacturers' recommendations. Fiber-base papers will require six to ten minutes. Again, be sure not to overfix.
3. After a minute in the fixer (two for fiber-base papers), you can turn on the room light. Allow final prints to remain in the fixer for the full recommended time, but you can remove test prints at this point.

Step 6: Assessing the Test Sheet.

1. Examine the test sheet to see which exposure yields the most-normal-looking contrast. Assuming the negatives were of standard density, you can use this exposure time (with the lens opening and height of the enlarger head remaining the same) for making future proof sheets. To guarantee that the results stay the same, put either a mark or a piece of masking tape on the enlarger support column at the correct head position.
2. If the proof sheet is too light, even in the 12-second exposure area (which is unlikely), make the test again with the lens set at $f/3.5$ or $f/4$. If the sheet is too dark, repeat the test at $f/8$.
3. Once the correct exposure has been determined, put a new sheet of printing paper into position and expose for the proper time. Then repeat the processing steps, this time leaving the print in the fixer for the full time.

Step 7: Washing and Drying.

1. Wash RC papers for no longer than five minutes; rinse fiber-base papers for two to five minutes and put into washing aid.
2. Place an RC print onto a clean, flat surface or a drying rack to dry. Drying time will be shortened if the print is wiped free of excess water with a rubber-blade squeegee.
3. Remove a fiber-base print from the washing aid and wash for the time recommended by the washing aid manufacturer. A longer wash would be necessary for an enlargement, but maximum permanence is not required for a proof sheet.

6

Making an Enlargement

When you make an enlargement, you are engaged in the most creative part of darkroom work, and there are many techniques you can use to give your print the look you want it to have. It is easier to master these techniques if you stay with a particular printing paper/developer combination, at least in the beginning. As you become familiar with how the combination works together, you will be able to move quickly beyond the trial and error stage and to discover how to get the most out of the paper and your negatives. You will also have a standard to guide you when you try something different.

Have an adequate amount of printing paper on hand. Start out with an 8″ × 10″ size; it gives you a standard-sized print and is easy to work with. If you are really plunging in and plan a lot of printing in your first few sessions, buy a 100-sheet box. However, if you are just getting your feet wet and plan on making only a few prints, a smaller package should be sufficient.

Examine your proof sheets and select the pictures you want to enlarge. For your first efforts, it is a good idea to choose negatives that look easy to print. This means that, as well as you can determine, they are neither over- nor underexposed and are normal in contrast. Wait until you have gotten the feel of making a print before you take on the trickier pictures.

The most efficient way to master the fundamentals of printing is to stick with one particular printing paper/developer combination. Begin with negatives that are properly exposed, and of normal contrast. Once you have learned how to print these well, you will be better equipped to handle the more difficult negatives. Photo: A. Balsys.

Preparation

Dry area.

1. Make sure the enlarger, timer, and safelight(s) are in place and plugged in.
2. Make sure both the top and bottom elements of the lens are clean. Use only photographic lens tissue for cleaning, and be gentle when using it. Avoid getting fingerprints on the glass, but if this happens, clean the lens right away, using lens cleaning fluid if necessary.
3. Clean the glass negative carrier, if you are using one. Also check items such as focusing aids, filters, and condenser lenses (especially the bottom part closest to the negative carrier) for dust, fingerprints, and the like.
4. Place the easel on the baseboard and have other accessories handy.

Wet area.

1. Lay out the trays so that you are working away from the enlarger, toward the wash area or holding tray.
2. Prepare working solutions of chemicals that require dilution. Follow manufacturers' instructions accurately.
3. Add solutions to the trays.
4. Check solution temperature.
5. Have accessories ready. These should include print tongs, thermometer, and paper towels (cloth towels get either too wet or too chemical-laden). It is also helpful to have on hand a rubber dish drainage mat or an extra tray (preferably 11" × 14") to use for inspecting test prints when they are pulled from the fixer.

Carefully *place your negative into the carrier. Handle the film by its edges only, to avoid getting your fingerprints on the image. A camel hair brush or compressed air will help you eliminate dust specks that might have settled on the negative surface.*

To get the sharpest prints possible, use a grain focusing device such as the one shown here. This indispensable darkroom tool magnifies the salt-and-pepperlike grain pattern of the projected negative, making it easy to bring the image into sharp focus.

Positioning and Focusing the Negative. Handle the negative only at the edges with clean, dry hands. Check it on both sides for dust. The best way to do this is to hold it under the enlarger light with the room light off. If you see dust specks, wipe the negative gently with a camel-hair brush or blow the dust off with compressed air. If the picture has horizontal composition, place the negative in the negative carrier so that the top of the picture is toward you. Otherwise, the image will be upside down on the easel. Place the carrier in the enlarger head.

With the room light off, take out a sheet of printing paper and place it emulsion side down in the easel, so that the image is projected onto the *back* of the paper. (Keep this sheet specifically for composing and focusing.) With the enlarger light on and the lens wide open, raise the head and turn the focusing handle until the image is the right size on the easel (with its blades correctly adjusted) and looks sharp.

Remember that if you print the full frame of a 35mm negative, it will not fill the entire area of an 8″ × 10″ sheet of printing paper and you will have a wide border on the bottom of the print. Trim off the extra width, if you wish, but it will not matter in any case if you mount the finished print. If you want a full 8″ × 10″ print, however, you must sacrifice part of the negative area. In this case, eliminate just enough of the picture to get the full 8″ × 10″ size. Reserve further cropping decisions for the trial print stage.

Use a heavy gauge piece of cardboard to make your exposure tests. Make sure that you hold the cardboard flat against the surface of the paper; otherwise light from the enlarger might spill onto areas you do not want exposed.

Making the Test Print: Step by Step

You make a test print by printing the negative onto the enlarging paper in a series of different exposures, or "test strips". Or you can cut the paper into strips, and expose and develop each one separately.

The test print is an invaluable guide to determining the correct length of exposure and the proper contrast grade. It must be made with a sheet from the same package of printing paper you will use for the final print. For the first several enlargements, use a full sheet for the test.

Step 1: Setting the lens. Stop the lens down to $f/8$ or $f/11$.

Step 2: Paper and Filters. With room light off and safelight on, insert the enlarging paper emulsion-side up into the easel. If, as recommended, you begin with a normal-looking negative, use a No. 2 paper, or variable-contrast paper with a No. 2 filter or no filter at all. Make sure the box or package of enlarging paper is closed before going to the next step.

Step 3: Exposures.

1. Cover all but one-fifth of the printing paper with the piece of stiff cardboard and expose for four seconds.
2. Move the cardboard to uncover another one-fifth of the paper and again expose for four seconds.
3. Repeat this procedure until the entire sheet has been exposed (for the last exposure in the series, the sheet will be completely uncovered). At the end of this procedure, the last strip uncovered will have 4 seconds of exposure, but the first strip will have been exposed for 20 seconds. In between, there will be exposures of 8, 12, and 16 seconds.

Step 4: The Developer.

1. Slide the paper into the developer. Make sure the paper is completely covered with developer as quickly as possible; press the print down gently with the print tongs if necessary.
2. Agitate gently by lifting a corner of the tray up and down, alternating between two corners to avoid creating a flow pattern.
3. Develop RC papers for 60 to 90 seconds and fiber-base papers for a full 2 minutes.

Step 5: The Stop Bath.

1. Grasp a corner of the print with the tongs, pull the print from the developer, and hold it over the tray for several seconds to drain.
2. Then slip the paper into the stop bath without allowing the tongs to touch the solution.
3. Let RC papers remain in the stop bath for 5 to 10 seconds and fiber-base papers for 10 to 15 seconds. Agitate gently.

Step 6: The Fixer.

1. Lift the print from the stop bath, drain, and place it in the fixer.
2. Agitate as before.
3. After one minute for RC papers and two for fiber-base papers, you can turn on room lights.

Step 7: Drying. Lift the print from the fixer and let it drain as well as possible, since the tonality of a wet print can be misleading. Place the print on the drainage mat or in the tray for inspection.

KODAK **PROJECTION PRINT SCALE**

PLACE THE PROJECTION PRINT SCALE OVER THE SENSITIZED PAPER ON THE EASEL. WITH A NEGATIVE IN THE ENLARGER, EXPOSE THE PAPER FOR 60 SECONDS. AFTER DEVELOPMENT, READ THE CORRECT EXPOSURE TIME IN SECONDS DIRECTLY FROM THE BEST APPEARING SECTOR ON THE ENLARGEMENT.

Made by EASTMAN KODAK COMPANY, ROCHESTER, N.Y., U.S.A.
PATENTS: U.S.A., 2,226,167; CANADA, 1942 • TM. REG. U.S. PAT. OFF.

Instead of making a series of test strips, you might find using a Kodak projection scale more convenient. This plastic device has wedge-shaped sections of varying densities that allow you to make a test print with one 60 second exposure, rather than a series of shorter ones. Once you have exposed and processed your test print, find the wedge producing the most accurate subject tones. Each wedge is marked with a number indicating the seconds of exposure needed to produce a straight print having the same density as the wedge.

Evaluating the Test Print

The lightest strip on the test print will probably be much too light to consider as an exposure guide, and the darkest may well be too dark. Examine the other strips to find the minimum exposure that gives a true black. If that strip also contains clean, detailed highlights and a well-balanced overall tonality, use the amount of exposure given that strip and the same paper grade (or filter) for the next step—the trial print.

If the test print was stopped down as far as $f/11$, the difference in relative darkness between adjacent strips should not be dramatic. But if one strip, perhaps the one exposed for 12 seconds, looks too light and the one next to it (exposed for 16 seconds) looks too dark, go halfway between the two and expose the trial print for 14 seconds.

If there are strong blacks in one or more of the strips, but the highlights look washed out and the overall tonality looks contrasty and harsh, you need to soften the print by using a No. 1 paper or filter. Some papers have the same speed (sensitivity to light) at different grades or with different filters. With these papers, you can still use the test print as an exposure guide when you change to a lower contrast grade. Again, look for the strip with the minimum exposure for true black and expose the trial print accordingly. If the speeds for different grades or filters are not the same, make a new test print.

When none of the strips have a full tonal range from black to white, you need a higher contrast grade. In this case, there is no true black on any of the test strips to use as a guideline, and your best bet is to make a new test print. Make it exactly as before, except use a No. 3 paper or filter. If this still fails to give an exposure strip with a full tonal range, go to an even higher contrast grade.

If none of the strips are dark enough, there are two things to do. If they are *much* too light, open the lens another stop and repeat the test print process. As a result, each strip will receive twice as much exposure as before at each four-second increment. On the other hand, if the 20-second exposure looks close to what the proper exposure should be, make another test print, but this time make the *last* exposure for 12 seconds instead of 4. This will give you a series of exposure times of 12, 16, 20, 24, and 28 seconds.

It is not likely that all the strips will be too dark unless the negative is very thin, or unless you failed to stop down enough. But if they are too dark, stop the lens down further and make a new test.

Sometimes one part of a negative is quite different in contrast from another part. In this case, a test print may be misleading, since the strip that looks right may not contain the contrast extremes. When printing such a negative, try to space out the strips so that those most likely to have the correct exposure time (usually the ones between the lightest and darkest strips) fall within that area of the subject that has the greatest contrast range.

Of course, any problem with sharpness will show up on the test print as well. If the print looks unsharp, the problem could be with the negative. Examining the proof sheet with a magnifying glass will help you determine this. If the contact print of the negative looks sharp, refocus the image. See Chapter 7 for other possible causes of lack of sharpness.

After you have acquired some experience in ''reading'' the test print, you won't need to use a full sheet of paper to make one; instead, one-half or one-fourth of a sheet may be sufficient. When you use a smaller piece, placement on the easel is very important. The test paper must be positioned within an area of the image that contains the negative's full contrast range.

There is an alternative to making a test print than the manner described above. This is to use the Kodak Projection Print Scale. The scale is a piece of film with a circular area divided into ten sections, each with a different density and a number inside. To use the scale, first position and focus the negative as described before. Then place the scale on a sheet of enlarging paper, positioning it so that it covers an area with a full contrast ratio. Set the lens to the aperture you want to use (Kodak recommends $f/11$ when using the scale) and expose the paper for precisely one minute. Process the paper normally, through the partial fixing process, and inspect the print. The number in the section that looks the best will be the number of seconds of exposure to give the trial print.

Technique Tip: Compensating for "Dry-Down"

Prints sometimes look darker after they have been dried, a factor that is often accentuated if they are heat-dried. This is more of a problem with matte papers than with glossy, since matte papers are much shinier when wet than when dry. If this "dry-down" factor occurs with the paper you use, it may take some trial and error to learn to compensate for it.

You can test for the dry-down factor by making three versions of a print in the following manner: Give one print the exposure indicated by the test and trial prints, make another print with two seconds less exposure, and make the third print with two seconds less exposure than the previous one. If one of the latter two prints looks better than the first one when dry, make that amount of compensation (at that particular aperture).

Burning-in and Dodging

It often happens that the overall contrast and density of a print is correct, but there are "hot spots" (areas that are too white) and/or small areas that are too dark. It may be that someone in the picture is wearing a light-colored shirt that prints as almost pure white in an otherwise normal-looking print, or perhaps someone is turned away from the light source and the skin tones of the face are too dark. The solution in these cases is to change the amount of exposure given only those particular areas, by employing the techniques known as burning-in and dodging.

Burning-in means giving extra exposure to a portion of the print. To do this, you first give the print the correct amount of overall exposure, then you allow the light to fall on the hot spot while holding light back from the rest of the print. Take a stiff, non-white piece of cardboard (an 8″ × 10″ piece is good for this purpose) and punch a small hole in the middle. You can then hold the cardboard under the lens and allow light to fall only on the area that requires additional exposure. When you do this, you must keep the cardboard moving slightly but constantly in a circular motion, otherwise, there will be a sharp line between the part of the print receiving extra exposure and the adjacent areas.

Burning-in is also necessary when there is a falloff of light at the corners of the print. In this case, a piece of cardboard is held with a back and forth motion to permit the extra light to fall on the corner that needs it.

If the area to be burned in has an irregular shape, it may be helpful to cut a similarly shaped hole in the cardboard.

Dodging means to hold back exposure from part of the paper area. It is done while the basic exposure is being made, and it requires a dodging tool. This tool is easy to make. Take a thin, rigid wire, such as a portion of a clothes hanger, and tape a piece of cardboard to the end. Cut the cardboard to match the shape of the area to be dodged. Or you can buy a dodging kit, which comes with attachments of various shapes and sizes. The dodging tool must also be kept in motion to prevent its outline from showing on the print. If the area being dodged is roughly circular, a ball of cotton can be a useful dodging tool; and since its edges are fuzzy, it helps prevent such an outline.

Experiment to find out just how much burning-in or dodging is required for a particular print. A helpful guide is to use one-fourth or one-half of the basic exposure time as a control unit. Thus, if overall exposure time is 16 seconds, you could start out by dodging for the first 4 seconds or burning-in for 8 additional seconds. If this still is not enough, dodge for an additional four seconds or burn in for an extra eight seconds on the next print.

Practice before you apply these techniques to an actual print. You can do this by swinging the enlarger's red filter into position, which will enable you to see the image without exposing the paper. You can then set the timer and practice the procedures described above until you get the feel of them.

You can correct the rendition of overly dark areas of your image by holding back light during exposure, or dodging. This technique can enliven an otherwise dull print, but is easy to overdo. In this print, the light area around the boy was produced by dodging. Photo: N.J. deGregory.

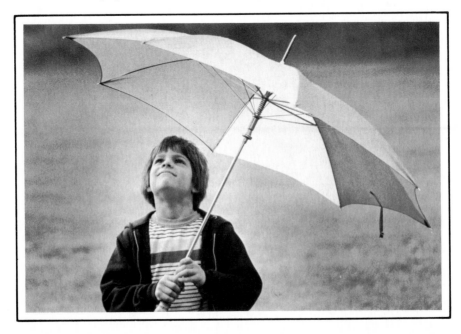

The Trial Print

When you have analyzed the test strips and have decided on length of exposure and contrast grade, it is time to make a *trial* print to see if the choices were the right ones and if there are any other problems to resolve.

Make sure the lens opening is the same as for the test print, then make the proper exposure. Process the paper the same way you did the test print, except this time, fix it for the full amount of time recommended by the fixer manufacturer.

Accuracy of exposure. Do not accept a too-light or too-dark print just because it is "pretty close" to what you want. It takes only a little patience to make another print that will be better. If the trial print looks too light or too dark, compare it with the test strips. Look at the strips that are a step lighter or darker than the one on which you based your exposure. The amount of exposure given one of these strips may now appear to be a better choice.

If the next step up or down is definitely too light or too dark, change the exposure by two seconds instead of four. With a little experience, you will be able to readily figure out such adjustments when they are necessary. Remember that it is not a good idea to let a decrease in exposure reduce the exposure time to under eight seconds. When exposures get too short, an error of even a fraction of a second can throw the exposure off.

The correct way to alter the relative darkness of a print is always to change the exposure time, not the length of development. The print should always be developed fully.

Technique Tip: Keeping Notes

It is very helpful to make notes while you work. In a notebook, or on the back of the printing paper, write down the lens opening, contrast grade, and length of exposure used for each final print. If you use a variety of papers or developers, or use a developer at different dilutions, also write down which of these are being used. If you use any control techniques, such as burning-in or dodging (see discussion later in this chapter), also write down the pertinent information.

If you write on the back of the paper, write along the edges, in the margin area. Use a soft-lead pencil. Make the notes before the paper goes into the developer, and don't press down hard with the pencil.

Contrast. Refer again to the standards applied when evaluating the test strips. A print that is too low in contrast will have an overall lack of crispness with muddy-looking blacks and dull, excessively gray highlights. To compensate, first go up one contrast grade for another print, then go up another grade if the resulting print still looks too flat.

A print that is too high in contrast will have a harsh, glaring look and highlights that lack texture or detail. Try a No. 1 paper or filter to compensate. If this is not sufficient, try an "O" grade paper, which is even softer.

Contrast control is often easier if you use variable-contrast filters, since many of these come in half-grade increments. Then, if a print is a little too soft with a No. 2 filter but too hard with a No. 3, you can use a 2½ filter, which should give you a print that is right on the mark.

It is often asserted that print contrast can be affected by the degree of dilution of the developer. That is, if a developer that is normally diluted 1:2 is used full strength, it will result in a print with more contrast, and if the same developer is diluted 1:4, for example, the print contrast will be softer. This is an overrated technique for contrast control, although it may work for you if only a slight contrast change is required.

Remember that if the film was correctly exposed and developed, it should print best on a No. 2 or No. 3 paper or with the equivalent filter. If you frequently have to go to a higher or lower grade to get a good print, there is a problem either in the way you are exposing with the camera or in your processing technique. See Chapter 3 for a discussion of negative contrast problems. Of course, there will be times when the *subject* contrast is so great that normal exposure methods with the camera will yield a negative with high contrast. See Chapter 8 for a discussion of how to deal with this.

Composition. When you look at the trial print, you have a chance to "revisualize" the picture by evaluating the composition. If something is missing, there is nothing you can do at this point, but it is more likely that there is too much in the picture. Photographers often stand too far back from their subject, so that the composition is not "tight" enough, or they allow distracting elements to appear within the frame, or they fail to see where the center of interest should be placed.

Take all these factors into account when you examine the trial print. If you decide to "crop" the picture, raise the enlarger head so that only a portion of the image fits within the area outlined by the easel. Next position the easel to get the composition you want. Remember that once the position of the enlarger head is changed, you can no longer use the same exposure time, hence you must make a new test print.

Of course, the best time to compose is before you click the shutter on the camera, and the reevaluation you do when you look at the trial print can help you learn to do this.

The Final Print

The final print is simply the last of the series of trial prints, the one in which exposure and contrast grade, as well as control techniques and cropping work out right. When you get a print that is satisfactory, it must go through these additional processing steps:

Washing aid. A resin-coated paper can be washed as soon as fixing is complete, but a fiber-base paper must be treated with a washing aid. Follow the manufacturer's recommendations carefully. Agitate while the print is in the tray.

Washing. Wash an RC paper for no more than five minutes. If the print is made on fiber-base paper, wash for 20 minutes if it is single-weight, and for 30 minutes if it is double-weight, regardless of the instructions that come with the washing aid. This will help guarantee that the prints will last indefinitely. If such permanence is not required, wash according to washing aid instructions, which often recommend a shorter washing time.

Refer to Chapter 4 for a discussion of washing methods and print washers. A vertical washer does a more thorough job than other types, but most washers can be effective if you avoid washing too many prints at a time. Since the washing time for RC papers is so short, and since it is not advisable to let them soak for very long, it is a good idea to wash each print as soon as you make it; in other words, wash them one at a time rather than letting them accumulate in a holding tray.

If you wash fiber-base papers for the long periods described above, it is not practical to wash them one at a time. In this case, a holding tray is very useful. It is better to hold the prints and put them all into the washer at the same time than to put one print into the washer and add others as each is ready. Each print you add will bring with it a new dose of residual fixer, which will contaminate the other prints in the washer. In addition, the washing time for *all* the prints will have to include the full time required to wash the *last* print that goes into the washer.

Don't allow too many prints to accumulate in the holding tray. They will have to be kept separated from each other in most types of washers and this is more difficult with numerous prints.

Drying. The easiest method for drying RC papers is to place it on a clean, smooth surface and wipe it with a rubber-blade squeegee, then leave the print face up on a clean surface, a clean towel, or piece of blotter paper. It will take a half hour to an hour to dry. Even if the paper is not squeegeed, it should not take much more than an hour to dry.

RC papers should not be heat-dried unless you need prints in a hurry. In that case, you can dry them on a ferrotype-plate electric dryer *only if* the heat is kept under 32 C (90 F), and *only if* the print is dried with its emulsion against the canvas apron. RC papers should never be ferrotyped.

Refer to Chapter 4 for the devices and methods for drying fiber-base papers.

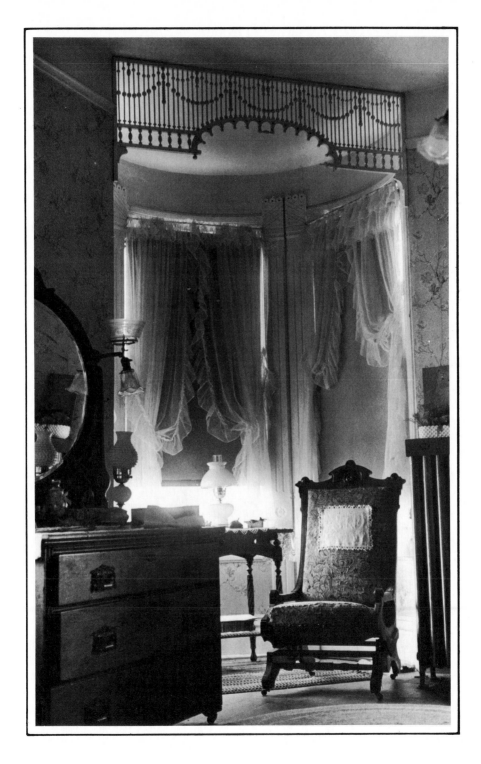

Your final print should have the contrast, exposure, development and composition necessary to get your photographic idea across as strongly as possible. Photo: K. Tweedy-Holmes.

7

Troubleshooting

Any problem with the negative will result in a problem with the print as well. Sometimes, as in the case of minor contrast difficulties, the trouble is easily solved. In other cases, such as a fogged negative, or one with areas with no detail whatsoever, nothing can be done.

If you process your film carefully, you will seldom have any unpleasant surprises when you view the negatives. However, problems may occur at one time or another. Some of the consequences of incorrect exposure and development were described in Chapter 3. Here is a guide to the likely causes and cures of other problems you may encounter.

Dust on the negative during exposure causes white spots to appear on the print, as shown at left. These dust spots can be removed by spotting, as described in chapter 8. Whenever possible, though, save yourself the trouble of spotting by brushing or blowing dust off your negatives before you put them in the enlarger. Photos: B. Sastre.

The Negative

Fogging. If there is an overall grayish look to the negative, light probably reached the film while it was being loaded into the developing tank. It is also possible, though much less likely, that you used outdated film. The cure is to make sure you load the developing tank in absolute darkness or that the film is fresh.

If there are black streaks along one side of the film, or if the film comes out of the developer part negative and part positive (the Sabattier effect), light reached the film while it was in the developing tank. This means that the lid came off the tank at least partially sometime during development. If this occurred, you won't need to view the negative to know that it happened.

If dark streaks are scattered through the negative area, light got to the film through the camera back while loading or unloading the camera, or else direct sunlight got through the lens. The solution is to be careful when using the camera.

Milky appearance. This is due to serious underfixing. Make sure that your fixer is fresh and that the film is in the fixing bath for the proper length of time.

If your negative has a black streak through the image, as shown here, chances are that light reached the film through the cameras back as you were loading or unloading. To avoid this irreparable problem, make sure that you advance the film to frame one before you shoot. Also, rewind your film completely before you open the camera. If the problem persists in spite of your efforts, take the camera to a repair shop—you probably have a light leak in the camera back.

If you have intermittent scratches on your roll of film, they are probably the result of improper handling as you hung the film to dry or as you cut the negatives into strips for storage. If the scratches run the entire length of the roll, there was some grit caught in the light trap of the film cassette, or on the pressure plate of your camera.

Spots. Clear spots indicate that there was dust on the film while it was in the camera. If there are actual pinholes in the negatives, the stop bath was much too strong. Make sure the inside of your camera is clean, or mix the stop bath solution more carefully, as the case may be.

If the spots are larger than dust specks, and if they are not completely clear, they are probably due to air bubbles on the film during development. Be sure to tap the tank on a hard surface after the developer is poured in, and agitate properly. Yellow spots indicate that the air bubbles occurred in the fixing bath. Again, tap the tank when the solution is poured in and agitate consistently.

If there are much larger spots or areas of the film that failed to develop at all, portions of the film were sticking together during processing. Be sure that the film is loaded correctly onto the developing tank's spiral reels. Do more practice loading if necessary.

Scratches. If there is a scratch along the entire length of the roll, it is the result of dirt or sand in the camera or on the lip of the film cassette, or of a jagged surface somewhere along the film path in the camera.

If the scratches are smaller and irregular, they may be due to rough handling either when the film was being loaded onto the spiral reels or when it was being hung up to dry or cut into strips. Be very careful to handle film only at the edges. Also use a hardening fixer.

The irregular pattern you see across the surface of this image was caused by reticulation—extreme change in solution temperatures during processing caused the emulsion to swell then shrink rapidly, warping and cracking as it did so. There is no way to undo the damage once it has occurred; keep your solutions at the right temperatures, and monitor the wash water regularly, making sure that it does not suddenly become too hot or cold.

More Negative Problems

Crescent marks. These are small, curved marks that occur because the film was crimped when being loaded onto the spiral reels. Again, the solution is to be more careful and to practice loading if necessary.

Streaking. Dark streaks that start at the sprocket holes are due to excessive agitation; light streaks that reach out from dense parts of the negative are due to insufficient agitation. The solution in both cases is obvious.

A light streak that runs along one side of the roll of film is caused by uneven development or by insufficient developer in the tank to completely cover the film. Be sure and use the correct amount of developer, and adhere to time, temperature, and agitation requirements.

Mottled look. This is another problem that may be due to insufficient agitation. Other possible causes are out-of-date film or exhausted developer. Again, the cures are obvious.

Stains. If the negatives look all right after processing, but yellow or brown stains appear later, the film was not adequately fixed. Make sure the developer is fresh, and follow manufacturer's instructions about fixing time.

If there is an overall yellow look to the negatives, the developer may have been exhausted or contaminated with fixer, or the fixer may have been contaminated with developer. Make sure the developer is fresh, and use storage containers for only one kind of chemical. Be sure film is adequately rinsed with water or a stop bath before pouring in the fixer, and be sure utensils such as stirring rods, thermometers, and funnels are clean before they are used with a chemical.

Unexposed (clear) negatives. If the entire roll is completely transparent, the film got no exposure at all, which means the film probably failed to advance in the camera. Make sure the leader is properly engaged on the take-up spool before you start to shoot. If only some negatives on a roll are clear, your camera probably has shutter problems. With no film in the camera, look through the lens to see if the shutter opens properly each time the button is pressed. If it doesn't, have it fixed.

Water marks. These may be dark outlines on the film, or grayish spots. They may be caused by water drops on the film while it dries, or by water splashed onto the negatives after they dry. The solution to the former problem is to use a wetting agent before drying the negatives; the cure for the latter is not to keep negatives in the open. They should be taken out of the negative holders only for enlarging, and they should be kept where chemical or water splashes cannot get to them.

Jagged or branchlike lines. These are due to static elecricity. They can occur when the film is being advanced or rewound in the camera, especially if it is done quickly in dry weather. It may also happen in the darkroom if the film is unrolled rapidly, especially if the air is very dry. If these lines appear at the end of the roll of film, it is because the tape holding the film to the spool was pulled off too quickly. The solutions are to handle the film carefully in dry weather, and to cut the film loose from the spool (see Chapter 3) rather than pull the tape off.

Reticulation. This is a pattern of irregular lines or cracking in the emulsion. It happens when the film is subjected to extreme temperature changes during processing. Reticulation is much less likely to occur with today's films, but it is still possible for it to happen during the washing process if a sudden surge of hot water comes through the faucet.

Dirt dried onto emulsion. This can occur if the water used for washing the film was contaminated with sediment or other dirt particles. If this is the cause, attach a filter to the faucet or use a rubber hose with a built-in filter (available at well-stocked photography supply stores). If this is not possible, buy bottles of distilled water for use in the final rinse. In this case, you will also need to use distilled water to dilute the wetting agent. In fact, you may need to use distilled water for all chemical mixing.

Dust or cat hairs or other objects can be deposited onto the emulsion while the negatives are drying, particularly if the drying area is a place with too much air circulation or is too dusty.

The Print

Fogging. An overall gray tone is probably caused by outdated paper or by the paper being exposed by a dim light source, such as the safelight or a light leak in the darkroom. The paper you find on the photo store's shelves is not likely to be outdated if it is a commonly used type; it is more likely that the paper will become dated by being stored too long in your own storage cabinet. To solve this, simply buy in small quantities if you print infrequently.

If you suspect that your safelight or a darkroom leak is fogging paper, refer to Chapter 1 for tests on safelight safety and darkroom light-tightness. Remember that safelight fogging can be very subtle. Instead of a noticeable gray tone, it may result in very slightly veiled highlights. Be sure to use the proper filter for the safelight (an amber OC filter for most papers), to use no more than a 15-watt bulb, and to keep the safelight at least four feet away from any place the paper will be in the open, including the processing trays.

If the paper is black or nearly black when it comes out of the developer, or if it is black around the edges with streaks reaching toward the center, it was exposed to a strong light source, most likely the room light. This means that a box of paper was left open or was not closed tightly enough. Unless you make it a rule always to close the box as soon as a sheet of paper

An overall grayish cast on printing paper is usually caused by a safelight that is too bright or too near the printing area. It also might be caused by light leaks in the darkroom. Extremely dark areas such as the one shown here, might happen should you forget to close your paper box properly before turning on the room lights.

Black spots on the print can happen if there was dust on the film while it was being exposed in the camera, or from pinholes in the negative caused by the action of an over-concentrated stop bath. These marks can oftentimes be etched out of the print, as described in chapter 8.

is removed, it is almost inevitable that you will one day turn on the light with the box open. The black wrapping that encloses the paper will not protect it much, and often many more than just the top few sheets are affected.

Even with the room light off, an irregular fogging pattern may occur if an opened box of paper is kept too close to the enlarger while you are focusing the negative. And once packages or boxes of printing papers have been unsealed, the paper can be fogged if the boxes are left too long in a brightly lighted room. Store the packages in dark closets, cabinets, or paper safes.

Spots. White specklike spots are primarily due to dust on the negative, and indicate that more care is required in cleaning the negative before enlarging. Small black spots on the print can result from clear spots on the negatives, caused by dust on the film when it was in the camera, or from pinholes in the negative, caused by an excessively strong stop bath. See the sections on spotting and etching in Chapter 8 for methods of dealing with small white or black spots.

Grayish spots, or spots that are white with a grayish fringe, indicate that air bubbles were on the print in the developer because of insufficient agitation. Darker spots may be due to air bubbles while fixing, again because of insufficient agitation, or to light spots on the negative, which can be caused by air bubbles on the film while it is being developed. Small, irregularly "outlined" areas may be due to water spots that dried on the film. Use a wetting agent before hanging the film to dry, and be careful to keep the negatives out of reach of potential water or chemical splashes.

If your print seems fuzzy and out of focus even though the negative itself is sharp, and you have focused the enlarger properly, make sure that the enlarger head does not slip after you have focused. Carefully examine the print itself—if it is out of focus on one side only, your enlarger may be out of alignment. The negative stage, lensboard and baseboard ought to be perfectly parallel. Use a carpenter's level to check for proper alignment and adjust the enlarger head until all four corners and the center of the projected image are equally sharp.

More Print Problems

Lines. White lines on the print are caused by scratches on the film base (the shiny side) or by a hair or thread on top of the negative while it was in the negative carrier. These lines can sometimes be spotted out (see Chapter 8) if they are not too extensive or too thin, although this is a trickier and more difficult task than getting rid of spots.

Black lines on the print are due to scratches on the film emulsion. If the scratches are not too severe, their effect can be minimized by spreading a light coating of petroleum jelly over the area on the film base containing them. This must be done delicately and carefully, and the jelly must be cleaned off after the enlargement has been made. There are also commercial solutions available that can be used in the same way.

Fading. If the print lightens too much before drying, it is because the fixer was too strong or because the print was fixed much too long. Manufacturers' mixing instructions must be followed accurately, and prints must not be left to soak in the fixing bath.

If the lightening occurs sometime after drying, it is because fixer was still in the paper, and the answer again is to be thorough when washing.

Stains. Yellowish or brownish stains can appear on the print for a number of reasons. Some of the most common are: excessive development or overused developer, inadequate fixing or exhausted fixer, or using a stop bath that is much too strong. If the stains are not apparent at first, but appear some time after the print is completely processed, it means that not all of the fixer was removed from the paper. If the stains are accompanied by darkened highlights, inadequate fixing is to blame.

Lack of sharpness. First, lack of sharpness in the negative itself must be ruled out. Examine the contact sheet with a magnifying glass (special magnifiers are sold in photo stores). If you are satisfied that the negative is sharp, and that you have focused correctly (if you consistently have trouble focusing, get a focusing aid), there may be some problem with the enlarger itself. If it is not sturdy enough, there may be some slippage of the head on the support column. Or the head may move slightly when filters are changed.

If there is an overall blurriness to the image in each print you enlarge, the enlarger may well be out of alignment. Use a carpenter's level to check for this at the baseboard and the lens mounting. Ideally, the negative stage should be checked as well. If this can't be done with a standard spirit level, you can get the Omega enlarger alignment tool, which permits access to the negative stage.

If the print is partly sharp and partly blurred with a doubling of the image, the negative is buckling in the carrier due to excessive heat. This can be solved by using a glass negative carrier.

Overall flatness, lack of rich tonality. This may be due to insufficient development. (Other contrast problems are discussed in Chapter 6.) Always give the print full development: 60 to 90 seconds for RC papers, two full minutes for fiber-base papers.

If your print looks flat overall, or seems not to have any richness in the shadow areas, you may have pulled it from the developer too soon. Make sure that your fiber based print gets two full minutes of development. Most resin coated papers will develop fully in one to one and a half minutes. Read the manufacturer's instructions regarding development time, and follow them.

8

Beyond the Basics

Ideally, each negative you enlarge could be printed "straight," without requiring any special techniques or any contrast compensation, to get the best print. But few negatives are that perfect, and it is important to know some of the methods you can use to deal with the problems that can occur, or simply to make a better-looking print.

Technique Tip: Vignetting

A central area in a print, such as the face in a portrait, can be emphasized by eliminating the background. To do this, take a stiff piece of cardboard and cut a hole in it the shape of the area to be highlighted.

During exposure, hold the cardboard under the lens, moving it slightly but constantly, to avoid getting a sharp outline. Allow light to reach only the chosen area.

The surrounding part of the print will be white. If you want it to be black, first make the print as described. Then:

1. Remove the negative from the enlarger.
2. Use a dodging tool to prevent light from reaching the highlighted area as you burn in the background until you have the effect you want.

Vignetting is a technique used to bring the viewer's full attention to the subject. The technique essentially consists of using a mask to dodge all but the central portion of the image, leaving a white surround. If you want a black surround instead, take the negative out of the carrier after exposure, and burn in the required areas, as suggested in the technique tip above. Photo: K. Tweedy-Holmes.

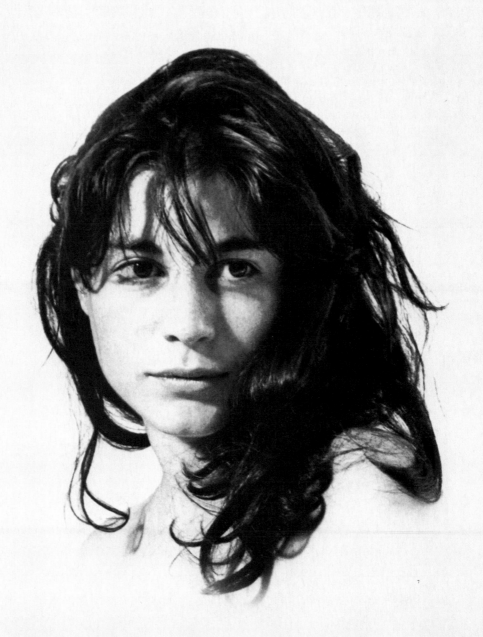

Special Techniques

Spotting. This may be more truly called a basic rather than a special technique since it is one that has to be applied all too frequently. Spotting is a method for getting rid of white spots, usually caused by dust on the negative, and these spots will occur on many of your prints even when you take precautions to keep the negative clean.

The materials you need are a spotting dye, which is sold in photo stores, and a camel-hair artist's brush (use a No. 0, so it will taper to a thin point). Make sure the dye matches the tonality of the print. For example, one popular and effective brand has numerical designations; the No. 3 is the basic formulation and is designed for papers with an essentially neutral tonality. It is probably all you need in most cases, but if a colder coloration is needed, you can add a few drops of the No. 2 to the No. 3. For a warmer tone, add a few drops of the No. 1 to the basic formulation.

The technique is as follows: Place the print to be spotted on a clean, flat surface. Have a dish ready with some drops of water on it. *Do not* try to apply dye straight from the bottle, even if the area surrounding the spot on the print is very dark. Instead, the idea is to *build up* the coloration of the spot. Mix the dye with the water so that a light gray mixture (it must be lighter than the area around the spot) is attained. Moisten the brush, and twirl it against the dish to get the sharpest possible point. The brush will

Spotone is a readily available, easy to use retouching dye used to ''spot'' out white dust marks on prints. This item is available in three different tints to suit a variety of print tonalities. The dyes can be combined to produce intermediate tones.

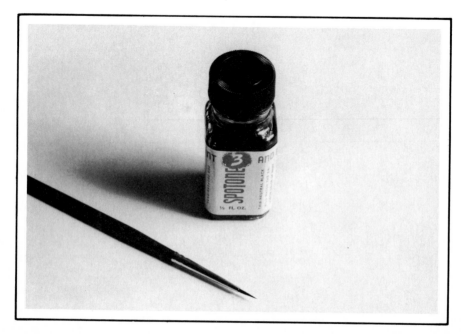

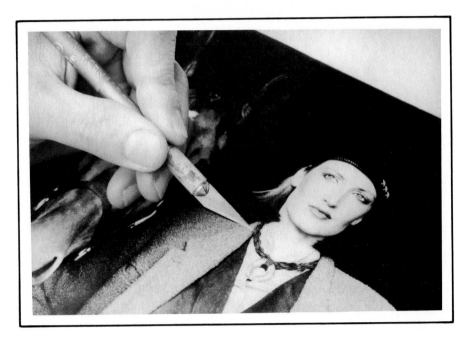

If you find an unwanted black spot on the surface of your fiber-based print, you might be able to remove it with careful etching. Use a fine pointed etching knife—make sure the blade is sharp and gently scrape the spot away. This technique does not work very well with resin coated papers.

work best if it is almost dry. Then keep applying the gray mixture in dots until the tonality of the print is built up to the proper degree. This must be done carefully, especially when the spot appears in a light area, because it is easy to get the spot too black. Once this happens, the spotting is usually quite noticeable.

Spotting is easier to do on prints that have not been fixed in a hardening fixer.

Etching. Sometimes a black spot appears on the print, due to a pinhole or clear spot on the negative. This clear spot can be spotted with dye on larger negatives, but this is not a practical procedure for 35mm film. The solution is to etch the spot off the print, if it is on fiber-base paper, and then spot the print as described above. Do not try the etching technique on RC papers.

The materials needed are an etching or Exacto knife, obtainable in artists' supply stores, and the spotting dye and brush. The process involves slowly and carefully scraping the black spot off the print. This leaves a white spot, which is then spot-toned. To restore a smooth finish to the paper, rub the spot with gum arabic or dab it with a solution of sugar and water.

Another method for eliminating black spots is to bleach the spot with a potassium ferricyanide solution (see "Local Bleaching" in this chapter), and then to spot it back to the proper degree of darkness.

Further Refinements

Using More Than One Filter. Often a print has different areas with different contrast problems: a landscape with a bright sky area, for example, or a scene that is partly in shadow and partly in bright sunlight. In these cases, it may be desirable to print the bright and darker areas with different contrast grades, and one way to do this is to use more than one contrast filter with variable-contrast paper.

First make separate test strips of the bright and dark areas to find out which contrast grade each needs. Perhaps, in the case of the landscape, the preferable filters are a No. 3 for the land area and a No. 1 for the sky. Insert the No. 3 filter into the enlarger head and make the proper exposure for the land area, while holding back exposure (using the dodging technique described in Chapter 6) from the sky. Then change filters and expose for the sky area, this time holding exposure back from the land.

Push processing. It is often thought that this technique can be used to boost a film's ISO/ASA rating, or speed. Strictly speaking, this is not true. A film's speed is determined by its degree of sensitivity to light, and there is no practical way to change this sensitivity. The only means by which a film's actual speed can be increased is by exposing it to mercury vapors or by exposing it to very dim light either before shooting or before processing. But the mercury method is quite dangerous, and the fogging is difficult to do with predictable results.

Push processing (using certain high-energy developers or extending the development time) will not produce an image if the amount of exposure was completely inadequate. What it will do is make the most of the film's inherent speed and exposure latitude. It builds up density in any area that has received enough exposure for there to be at least some detail. Thus, it

If you have a photograph that has large, light areas alongside moderately toned ones, as is the case in this picture you might need to use variable contrast paper and more than one filter to produce the best print of the scene, as described in the text.
Photo: P.J. Bereswill.

can be helpful in compensating for underexposure, but there is a price to pay for this: density will increase most in the highlights, and the result is a contrasty negative. Graininess is also increased.

As a guide to the extra development required for underexposure, increase developing time by 50 percent if the film was underexposed by one stop, and by 75 percent if the underexposure was two stops. These are not exact formulas, and the quality of the results will depend to a large extent on the circumstances under which the film was shot. For example, if you shot in bright sunlight with your camera set at the wrong ISO/ASA setting, resulting, for example, in a two-stop underexposure, you are more likely to get a negative with good detail than if the film was shot under low-light conditions.

If the underexposed film has valuable shots on it, it may be worth the slight expense and effort required to shoot a test roll, simulating the lighting and exposure factors of the underexposed roll. You can then develop the test roll with added development to see if you get the desired results. If not, it may still give you an indication of any further variation in development time To compensate for overexposure, experiment first with a 25 percent reduction in development time for a one-stop overexposure, a 50 percent reduction if the film was overexposed by two stops.

Flashing. Flashing is a technique for coping with overly bright highlights. There are two ways to do it. One is to flash the entire print. To do this, you must first determine how much exposure is required. Stop the enlarger lens down to its narrowest aperture and expose (with no negative in the enlarger) in test strip fashion for 2, 4, 6, 8, and 10 seconds. Develop the paper fully and fix the same as for a test print. When you examine the paper, look for the greatest amount of exposure that *does not* produce a perceptible tonality on the paper. This is the flashing exposure you will use.

To apply the technique, first make the normal exposure for the negative. Then remove the negative from the carrier, stop the lens down, and make the flashing exposure. Develop and process the print normally. The result should be a print with less glaring highlights.

The other method is called "local flashing," and it is more practical for many situations. For this technique, you need a penlight flashlight and a piece of dark-colored paper rolled into a cone shape with a narrow opening at the point. During flashing, position the paper cone over the flashlight to further concentrate the light.

Give the print the proper basic exposure as determined by test and trial prints, then expose the hot spot further with the penlight. For larger areas, it is better to use the enlarger light. Take an 8″ × 10″ piece of cardboard and cut out the shape of the area to be flashed, but make the cutout slightly smaller than the actual image area. Using the red filter, position the cardboard on the printing paper and remove the negative. With the lens stopped down all the way, swing the red filter out of the way. Keep the cardboard moving so that there is no sharp outline around the area receiving the extra exposure.

Glossing. The easiest way to get a high-gloss print is to use resin-coated paper, which dries naturally with a polished finish. To get a high gloss on fiber-base paper, you must print with a glossy-surface paper, and you must *ferrotype* the print after washing it. The ferrotyping process consists of pressing the print emulsion down against a smooth surface and allowing it to dry. A chrome-plated or stainless steel ferrotype plate, which is obtainable either by itself or with a platen heat dryer, is generally used. Heavy plate glass (not window or picture frame glass) also works very well.

The ferrotype plate must be clean, and it is helpful to polish it with glossing solution (obtainable in photo stores). It is also an advantage to soak the print for several minutes in a glossing solution. To get an even gloss, the print's emulsion must be in complete contact with the metal or glass surface. After the print is placed face down on the plate, squeegee it to remove excess water, then press it down with a roller (also obtainable in photo stores) to further remove any excess water and air bubbles and to insure firm contact.

Drying at room temperature will take several hours, although the process can be speeded up by letting a fan blow on the ferrotype plate. When the print is dry, it will pop loose from the plate. Do not try to remove the print prematurely. If you do, part of the emulsion will stick to the ferrotype plate. Drying can also be speeded up by using a heat dryer, but the heat must be kept low or the glossing may be uneven.

Usually, bleaching is done in small areas of the image, to add sparkle to eyes, hair and other naturally bright highlights. It takes some practice to master the technique of bleaching—follow the suggestions given in the text, and make your initial attempts on work prints. Photos: A. Rakoczy.

Local Bleaching. There will be times when certain areas of an otherwise normal print will be too dark. Often facial tones need to be lightened to make the most effective picture. One way of doing this is by bleaching the area that is too dark. To do this, you need a bottle of potassium ferricyanide, some cotton swabs, two or three fine-pointed artist's brushes (with no metal ferrule), and a 250ml (8 oz.) measuring cup.

Fill the cup half full with water and add small quantities of the ferricyanide powder while stirring continuously. Avoid breathing the dust, and if you get any of the solution on your hands, wash thoroughly. Expose and process the paper normally. After it has been in rapid fixer for a minute, two in standard fixer (using fiber-base paper), turn on the room light and lift up the print. Holding it across your hand, or in a tray held close to the fixing bath, apply the ferricyanide to the desired area with a brush or swab. After a few seconds, use another swab to apply fixer to the area, and inspect the print to see if you are getting the desired effect. If more bleaching is required, repeat the process. *Do not* bleach the area all the way to the desired lightness since the bleaching action will continue for a moment or two after the print has been returned to the fixer. Instead, when it looks as though the bleaching is almost to the desired point, put the print back into the fixing bath and complete normal processing.

Ferricyanide has other uses besides solving a serious print problem; you can also use it to add a little more sparkle to already natural-looking highlights. Used correctly and carefully, bleaching can be an important addition to your range of darkroom skills.

In the picture at right, careful use of potassium ferricyanide helped the photographer bleach out the distracting background information you can see in the unmanipulated print.

Mounting and Framing

As you learn to make fine-looking prints, you will probably want to display some of your favorites. The best way to do this is to mount or mat and frame the prints you want to display.

Dry mounting. The easiest way to do this kind of mounting, and the method recommended for RC papers, is with mounting tissues, which require only pressure (rather than heat) to seal the print to the mat board. Some of these, such as those made by 3M, allow you to reposition the print before bonding it to the board.

The other commonly used type of mounting tissue is waxy paper, which melts to form an adhesive when heat is applied. It can be used with a dry-mount press or an ordinary household iron. To use this method, you first attach the tissue to the back of the print by tacking it down in the center with the tacking iron of the dry-mount press or with the tip of the iron. Use the iron at the low synthetic fabric heat setting. After the tissue is attached, trim the borders of the print with a paper cutter or a razor blade-type cutting knife and ruler. It helps prevent board warping before attaching the print, if you heat-press the board in the dry-mount press or iron it to get rid of moisture.

When the print is in position, carefully lift up a corner of the print and tack down the corner of the mounting tissue to the board. Repeat this with each corner. Put the board with the print between two thin mounting boards and place it in the (preheated) dry-mount press. The temperature should be no higher than 99 C (210 F) for RC papers, but it can be higher for fiber-base papers. About 30 seconds is sufficient for RC papers; about a minute may be required for fiber-base papers.

If you are using an iron, again place a thin mat board on top of the print and iron, again using the synthetic setting, form the center outward. A considerable amount of pressure may have to be applied, but do not hold the iron in one place, since there is a danger of scorching the print.

Before mounting, you must first select a mat board. These come in a variety of colors and thicknesses and are available at art stores. Be careful when choosing colors, however, since you do not want the color of the mat board to draw attention away from the print. Usually, pure white is highly effective with neutral-tone papers, although a cream or beige board can complement a warmer print nicely. It is better not to position the print dead center on the board; this tends to make the top border seem larger than the bottom. If the bottom border is slightly wider than the top, the print will seem more nearly centered.

If you are interested in archival processing, use only 100 percent rag-content papers, such as Strathmore's or Bainbridge's Museum Boards, for mounting.

Wet mounting. This consists of using some kind of glue or spray-on adhesive rather than mounting tissue. The spray-ons are preferable to

The device shown in the top picture is a tacking iron. It is used to position and fasten dry mounting tissue to the back of a photographic print. You must keep the print in exact register with the tissue and use a piece of clean backing paper to protect the print surface as shown here. The print/tissue sandwich must then be "tacked" to the mount board. In the picture below, a print with tissue and board tacked in place, is being inserted into a dry mount press. This device uses heat and pressure to melt the tissue and bond the print to the board.

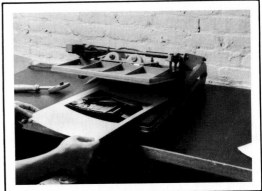

most glues and are easier to use. Especially avoid rubber cement if you desire any degree of print permanence. Rubber cement is easy to use, but it will cause stains in the long run.

Trim the borders from the print before applying the cement. When the print is positioned on the board, cover it with a clean sheet of paper and press down with a roller to make the adhesive secure.

Matting. A print can be secured to a backing board and then covered with another board that has a window cutout the size of the picture. Precut window mat and backing board combinations can be purchased in art stores, or you can make a cutout yourself with a mat cutting knife. If you use such a window mat, the print does not have to be dry-mounted on the backing board. Instead, the border can be left untrimmed, and the print can be taped down. Scotch Magic Transparent Tape is good for this purpose. Do not use masking tape; it will ultimately discolor the borders of the print.

A window mat, besides being an attractive way of displaying prints, has the added advantage of preventing the glass or plastic surface of a frame from touching the print. This is especially important with RC papers and color prints, because their emulsions may adhere to the glass in time.

Special Effects

Toning. One of the most dramatic ways of giving a different look to a print is to change its color with a *toner*. A true toner changes image tone by reacting chemically with the silver in the paper's emulsion. In some cases, as with selenium toning, this change serves to make the image more stable and long-lasting. Some products, which are sold as toners, are in fact dyes and change the overall paper color. Prints that are dyed will have less stability than toned prints, but this may be of little consequence if you get the look you want.

Not all printing papers tone equally well. Warm papers usually react more to the toning solutions than cold-tone papers. With resin-coated papers, the variable contrast variety often tone more readily than graded contrast papers.

Some of the commonly used toners include selenium, sepia, brown, copper, and blue. Both Kodak and GAF make a variety of effective toners. Some of these are single-solution toners. That is, the prints are simply soaked, with agitation, in a tray of working solution until the image changes color. An example of this is selenium toner. When mixed at a higher concentration (see instructions on bottle) than that used for print protection, they will give the print a brown-to-purplish look that is often quite pleasing.

The group portrait at left is a modern photograph done in a style that reflects a bygone age. The effect of pictures like this is usually enhanced by sepia toning, which gives the image a warm brown hue reminiscent of the tintype era. Photo: G. Kotler.

Technique Tip: Safe Handling of Toners

Toners are poisonous, and in many cases it is dangerous both to breathe the fumes and to get the toning solution on your skin. Toning should be conducted in well-ventilated areas, and print tongs and / or rubber gloves should be used. Read and observe the manufacturer's recommended safety precautions.

Be especially careful if you use Kodak Poly-Toner. It can penetrate the skin, and its hydrogen sulfide fumes can fog unexposed paper or film.

Some toners have A and B solutions, the first a bleach and the second a "redeveloper" which gives the print its new color. Sepia is one of the most popular and attractive two-solution toners.

Sometimes you can get a variety of effects with a single toner. For example, different degrees of dilution of Poly-Toner will give you different colors, from reddish to yellowish brown. Also, GAF Copper Intensifier gives hues from brown to red, or even blue, depending on the length of development or whether heat is applied (with a dry-mount press).

Edwal provides a line of dyes in a wide variety of colors. These will stain your hands, so be sure to use print tongs.

In many cases, variations of the basic colors can be obtained by using first one toner or dye and then another on the print. You will get better results if this combined toning is done in sequence rather than by trying to mix two toners or dyes together.

You will have to make adjustments in exposure times for those prints you want to tone. For example, selenium toning, when done to change image color, makes the picture look slightly darker, so you may need to reduce exposure time. On the other hand, many toners, especially those which include a bleaching step, will make a print look lighter, so the print may need to be slightly overexposed. A little experimentation will tell you how much of an adjustment to make.

Multiple toning can be accomplished by applying one kind of toner to a selected area of the print with an artist's brush, and then either immersing the print into another toner or brushing the second toner onto other areas of the print. Since the print should be washed after each application of toner in combined or multiple toning, RC papers are more convenient to use since washing time is only five minutes. Fiber-base papers should be washed for 20 to 30 minutes after toning. If you decide to tone a print that has already been dried, first soak it in water, for 5 minutes if the print is on RC paper and for 15 to 20 minutes if it is on fiber-base paper.

Multiple printing, done with either method described in the text, can produce startling or whimsical images that you cannot get any other way. If you try this technique, make sure that the images in each negative you use work well with the others. Photo: A. Balsys/L. Adamson

Multiple Printing. This technique consists of using more than one negative to make a single print. This can be done by printing first one negative and then another onto a single sheet of printing paper, or by *sandwiching* negatives (putting one negative on top of another in the negative carrier and printing them together).

You can use the technique to create the illusion that the image was made from a single negative. For example, if you have a landscape with a large sky area, you may want to include in it a cloud formation from another negative. To do this, make test strips of the areas of both negatives that you want to use. Next print the land area of the landscape, holding back exposure from the sky. After switching negatives, print the sky area of the second negative while holding back exposure from the unwanted parts. The effect will be much more realistic if the shots were taken under similar lighting conditions, and if the negatives are similar in contrast.

Make sure that the negatives are lined up correctly. You can do this by making a cardboard silhouette of the land area from the first negative as it appears on the easel. After making the exposure, swing out the red filter, turn on the enlarger light, and lay the silhouette in the proper position on the printing paper. Then, with the red filter still in place, line up the second negative, using the cardboard silhouette as a guideline. Remove cardboard before exposure. See the section on dodging in Chapter 6 for the proper procedure for holding back exposure.

You can also use multiple printing to create surrealistic effects by having overlapping images or bizarre juxtapositions of images on the print. If you use a slide for one part of the picture and a standard negative for the other, your print will have a combined negative-positive image.

When you sandwich negatives, it is easy to position the images the way you want them, but remember that exposure times will be greatly increased due to the added density of the combined negatives.

Textured Prints. There are two basic ways to add an unusual texture to your prints. One is to use a textured printing paper (see Chapter 4), the other is to use a texture screen or other textured material to add a pattern to the print. Many kinds of screens are available commercially. Some of these add an extremely grainy look to the print, others add a pattern or design. You can make you own texture screens, however, by using window screens, wrinkled plastic, patterned glass, gauze, glass smeared wth petroleum jelly, lace, stretched nylon, or any kind of fabric or substance that is not too opaque.

There are two ways to apply the technique. One is to place the texture screen directly onto the printing paper. You can make the effect more subtle by leaving the screen on the paper for only part of the exposure. With many of the screens, you can create a diffused-image effect by holding the screen just under the lens. The other way is to place the texturing material along with the negative in the negative carrier.

You can add texture to your photographs by printing directly on specially surfaced paper. You can give the illusion of texture by placing a patterned screen over the paper during exposure. The latter technique was used in this photograph; the photographer chose a screen surface that complemented the mood of the landscape. Photo: E. Stecker.

Photogram. You can use your enlarging paper to make prints that do not require the use of a camera at all, and achieve some extremely dramatic and imaginative results. Photograms are pictures made by placing objects directly onto the printing paper. When the paper is exposed by the enlarger light and developed, these objects will be silhouetted. The shapes you create can be the outlines of recognizable objects, such as hands, leaves, or keys, or they can be purely abstract. By using a combination of opaque and translucent objects, or by removing the objects for part of the exposure time, you can make the silhouettes pure white or a shade of gray.

To make a photogram, turn the room light off and the safelight on and place a sheet of printing paper into the easel. Swing out the red filter and turn on the enlarger light. Arrange the objects on the paper in the pattern you wish to reproduce in the print. You can experiment or make a test print to see how much exposure gives you the degree of blackness or shade of gray you want.

High-Contrast Prints. You can accentuate a picture with strong design elements by making a high-contrast print. To do this, you need litho film and litho film developer. If you process the litho film in a standard developer, you will not get the degree of contrast required for this technique to be really effective. Litho film is available in 4″ × 5″ and 5″ × 7″ sheets. The film can be handled in the darkroom by using a No. 1A (light red) safelight filter.

The simplest way to get an effective high-contrast print is to start with a negative that already has strong contrast. If your enlarger will accept

The simplest and in some ways most pure form of photographic image is the photogram. Making photograms does not involve the use of a negative at all—objects are laid directly on photographic paper which is then exposed to light. The objects block light, leaving a clearly defined rendition of their form when the paper is processed. Photo: C.M. Fitch.

High-contrast prints heighten the visual impact of photographs containing strong design elements and clearly defined forms. The high-contrast technique eliminates almost all of the mid tones, strengthening the graphic appeal of the image. Photo: H. Taylor.

4″ × 5″ negatives, or if you want to make a 4″ × 5″ or 5″ × 7″ contact print with the litho film, position the negative you have chosen in the enlarger's negative carrier. Focus on a white sheet, as you normally do, with the easel blades set for the size of the litho film. Then, making sure only the red safelight is on, position a sheet of litho film, emulsion (dull) side up, in the easel. If the easel has a light-colored base, place a sheet of black paper under the film to prevent reflections. You should make test strips, but some trial and error may also be necessary, since it can be tricky to determine the proper exposure. You need a sharp distinction between black and white areas, but overexposure can render this distinction less sharp than it should be.

Develop the exposed film in the litho developer. A typical developing time is 2¾ minutes at 20 C (68 F). Agitation should be gentle but continuous. When development is complete, put the film into a stop bath for 15 seconds, then fix in rapid fixer for 2 minutes. Wash for 20 minutes, then allow to dry thoroughly.

You will now have a *positive* image on the litho film, which will print as a *negative* image on printing paper. This may give you the effect you want, but if you want a positive image on the print, you must contact-print the litho film image onto another sheet of litho film.

An alternative method to the above is to contact-print the negative onto the litho film. To do this, place the black sheet on the enlarger baseboard and place the litho film on top of it. Put the negative, emulsion side down, on the film and place a piece of glass on top to hold it flat. Determine exposure by experimentation.

Index